The
Digital Photography
Companion

The
Digital Photography
Companion

DERRICK STORY

O'REILLY®

Beijing · Cambridge · Farnham · Köln · Paris · Sebastopol · Taipei · Tokyo

The Digital Photography Companion
by Derrick Story

Copyright © 2008 O'Reilly Media, Inc. All rights reserved.

Published by O'Reilly Media, Inc. 1005 Gravenstein Highway North, Sebastopol CA 95472

O'Reilly books may be purchased for educational, business, or sales promotional use. Online editions are also available for most titles (safari.oreilly.com). For more information, contact our corporate/institutional sales department: (800) 998-9938 or corporate@oreilly.com.

Editor: Colleen Wheeler
Copyeditor: Audrey Doyle
Interior Design: David Futato, Ron Bilodeau
Technical Editor: James Duncan Davidson
Cover Designer: Steve Fehler
Photographer: Derrick Story

Print History: February 2008, First Edition

ISBN-13: 978-0-596-51766-3
[F]
Printed in Canada

"Derrick Story has a unique gift for creating order out of chaos. Digital photography turns things upside down and even seasoned shooters need help. Whether you are a complete beginner or a photographer with experience, Derrick is the go-to guy. His new book fits perfectly into my camera bag and is going with me on all my assignments from now on. Derrick is just too damn tall to fit in my pocket."

– Rick Smolan, Photographer
Creator of *Blue Planet Run* and *America at Home*

Contents

CHAPTER 2 **How Does It Work?**

List of Tables

Preface

At this very moment, thousands of pictures are being recorded. Some of those images will be imaginative, but many will be slices of life that hold personal meaning for the photographer and are of little interest to most others.

We see pictures everywhere. They show up in our email, are embedded in web pages, span edge to edge on magazine covers, and flash by on TV screens. With so many people taking so many pictures, how do you distinguish your work from that of others?

The answer: start by learning how to work your camera. When it begins to feel like a natural extension of your vision, you'll be better prepared to embrace the world you see through its lens.

Remember how awkward it felt the first time you drove a car? You weren't thinking about your destination as much as you were trying to avoid careening off the side of the road. By learning the controls and practicing their use, you were soon maneuvering with skill and confidence.

If you operate your camera the way you've mastered your car, you will take better pictures. Instead of wondering which button to push and fiddling with the controls, you will focus on the world you see around you. And that's when magical things begin to happen.

Before you know it, you're embracing techniques to make your pictures look different. That's the Holy Grail of photography. And those differences can be such simple things: get super-close to your subject. Go outside at twilight. Turn off the flash indoors. Make running water look as soft as an angel's hair. Capture an expression of a loved one that is unposed, unrehearsed, and totally spontaneous. The possibilities are endless.

But you can't take these pictures if you don't know how to turn on macro mode, turn off the flash, make a long exposure, or switch to burst mode, just like you can't drive home if you don't know how to start the car, put it in reverse, back out, and then go forward.

Make your pictures look different. That's what you are going to accomplish with this book. You'll start by learning the controls on your camera and end by producing beautiful prints that you can show to the world. After that, there will be no limits to what you can do with your camera.

Chapter 1: What Is It? This drive begins like preparations for any vacation. You have to account for everything that's going to accompany you and know where it is. In Chapter 1, you'll learn about every nook and cranny on your camera. Or, if you haven't purchased a camera yet, you'll discover the features you need and—just as important—the ones you don't.

Keep your owner's manual handy when you first review Chapter 1. It will help you find where the flash control button is located on your particular model, for instance. Once you find that button, this book will show you how to use the different flash modes to take the pictures *you want*, not the ones the camera dictates.

Think of Chapter 1 as a detailed map. It tells you where things are and a little about what they do. It's designed for quick reference—to provide answers while you're on the road—so make sure you keep this book with you. It's designed to fit easily in your camera bag or your backpack.

Chapter 2: How Does It Work? By now, you've located the flash button on your camera, and you've even read about the different modes available, such as *fill flash* and *slow synchro*. Terrific—now, when do you use fill flash? What is slow synchro good for?

Chapter 2 will help you answer those questions. You're now well on your way to becoming close friends with your camera, and while you might not notice it, you've taken control of the situation. In the beginning, the camera made all the decisions. Most of the time they were adequate, but now you're in charge and your pictures are much better as a result.

Chapter 3: How to Shoot Like a Pro Here you'll learn more than a dozen important camera techniques. How do you take great outdoor portraits? How can you shoot architecture like a pro? Can you take action shots with a consumer digital camera? Chapter 3 is like an ongoing conversation during a long road trip, discussing the best approach for what lies ahead.

Chapter 4: I've Taken Great Pictures, Now What? So many good pictures never see the light of day. They remain trapped on memory cards or lost on hard drives simply because people don't know what to do with them. This chapter will help you master your computer the same way you tamed your camera.

Chapter 5: Printing Made Easy Just because your pictures now live on your computer doesn't mean they have to stay there. Printing is still one of the most artistic expressions of photography. And anyone can produce beautiful images worthy of framing. In Chapter 5, we'll take the mystery out of printing and get your work on paper.

By the time you've experimented with the techniques outlined in *The Digital Photography Companion*, you'll have journeyed well beyond your peers. And the pictures you take will not only become personal treasures, they will also be admired by others.

For more photography tips based on techniques covered in this book, visit *www.the-digitalstory.com/dpc*. You can also participate in the monthly photo assignment with results published on The Digital Story, contribute grab shots, and if you figure out a great photo technique that you want to share with the world, send in a "How I Did It" entry.

If you're not quite ready to share your work yet, enjoy our weekly podcasts featuring camera techniques, software, and interviews with photographers passionate about their craft.

The Digital Story is for camera enthusiasts of all levels. Become a part of our virtual camera club today.

What Is It?

FEATURE AND COMPONENT COMPARISON

The first steps toward taking control of your photography are to become familiar with your camera's components, and then to learn exactly what they do. This chapter helps you do just that. It explains the important components and features that will set you on the path to mastering your digital camera.

If you're just getting started with digital photography, this information can also help you pick the right camera model. I like to divide digital cameras into three broad categories: compact, Digital Single Lens Reflex (DSLR), and hybrid. As you progress from compact to DSLR, you'll find that the tools become more sophisticated. The third category, hybrid, is an example of how digital imaging is converging with other technologies. These devices can be quite useful, but they won't usually serve as your primary camera.

I've listed the features and components in this chapter in alphabetical order. When shopping for a new camera, you can use this feature list to determine the model that best suits your needs. But more important, you can consider this chapter to be a friendly companion to your owner's manual, helping you master the controls of the camera you already have.

Which Should I Choose: Compact or DSLR?

Compacts, and their bulkier DSLR brethren, each have their advantages. Often, people ask, "Which camera should I choose?" Over time, most avid photographers will own both types. But if you're looking to make a choice before that glorious day, there are a few things to consider.

The following discussions touch on the salient features of both compacts and DSLRs. Studying these sections will help you decide what type of camera you need now, and what you may consider in the future.

Pros and Cons of a Compact Camera

Form factor is a primary consideration when shopping for a compact camera. Is it small enough to accompany you during daily life? You've wasted your money if your point-and-shoot is at home on the dresser when your child takes his first steps at grandma's house.

> **TIP ▼**
>
> The best camera is the one you have with you. Many of the illustrations in this book were captured with compact cameras. (See the Appendix for the table listing all images with their metadata.) Don't believe that you have to have a $5,000 DSLR to make great photos.

Which should you choose?

OVERVIEW OF CAMERA CATEGORIES

The compact digital camera combines versatility with good performance. DSLRs are bulkier, but they also produce the best image quality, especially in low light. The main advantage to hybrids is that they win the award for "camera most likely to be in your pocket" while on the go.

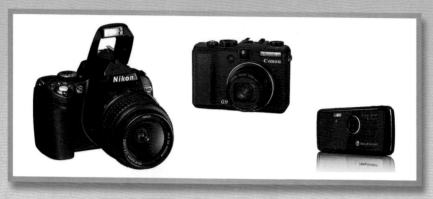

Examples of three basic types of cameras:
a Nikon D40X DSLR, a Canon G9 compact, and a Sony Ericsson K850i hybrid

Compact

Compact cameras are perfect companions for vacationers, parents, and photographers who like to record life as it flies by. Because compacts fit easily into purses, backpacks, diaper bags, briefcases, and even shirt pockets, your odds are good that you'll have a camera on hand when that perfect grab shot presents itself. That's why I recommend that all photographers pack a compact, regardless of other cameras they have in their arsenal.

These pint-size wonders do have their trade-offs. The zoom lens is permanently attached to the camera and often isn't as powerful as the removable lenses available for DSLRs. It's also more difficult to add external flashes and accessories such as filters to compact cameras.

The biggest trade-off (compared to DSLRs) comes with low-light performance—or I should say, lack of performance. At low ISO settings, such as 100 and 200, compact cameras show little image noise—the stuff that looks like grain. But as you push the camera's light-gathering sensitivity to ISO 400 or more, as required in low-light settings, you'll notice degradation in picture quality. DSLRs, on the other hand, perform well up to ISO 1600. So, if you enjoy shooting indoors without a flash, you may be disappointed with the images from your compact.

Happily, though, megapixel power is no longer a trade-off for portability. Most compacts these days provide at least a 6-megapixel sensor, and 7–10-megapixel models have become commonplace. This is more than enough resolution for snapshots and enlargements. And the really good news is that high-quality compacts usually cost less than $400.

DSLRs

Just because you don't earn your living taking pictures doesn't mean you don't want the capabilities that pros want in a camera. DSLRs look and behave similarly to the 35mm film SLRs of yesteryear.

DSLRs enable you to quickly switch from one type of lens to another by simply removing one from the camera body and attaching another. With dozens of optics to choose from, this provides tremendous flexibility. Another feature is that you compose your picture through the same lens that you use to capture it. "What you see is what you get" is the battle cry with DSLRs.

Inside the camera body, manufacturers have packed sophisticated electronics to enable you to capture pictures quickly (with virtually no shutter lag), in rapid sequence (burst modes of a dozen pictures or more are not uncommon), and with unparalleled image quality, in terms of both megapixels and noise reduction. If you want to shoot in low light without a flash, DSLRs are the best tool for the job.

Another bonus is that RAW mode is a standard feature for DSLRs. These "unprocessed" files enable you to extract every drop of image quality from your photos. Most compacts don't offer this luxury.

Often, you can add other goodies to your DSLR kit, such as wireless external flashes, Wi-Fi image transfer capabilities, and a host of sophisticated accessories that include remote releases and macro lighting rigs. DSLRs start at around $600 and can quickly escalate to a few thousand dollars. Keep in mind that optics and accessories can add substantial heft to the bottom line.

Hybrids

As digital imaging components become smaller and more energy-efficient, technology companies are able to incorporate them into a variety of devices. You can now buy a mobile phone that also has megapixel picture-taking capabilities, and many digital camcorders include multimegapixel sensors, memory cards, and even electronic flashes.

Most photographers would not rely on camera phones or digital camcorders as their primary picture-taking tools. But as the technology evolves, these tools can become useful additions to your ever-broadening arsenal of imaging devices.

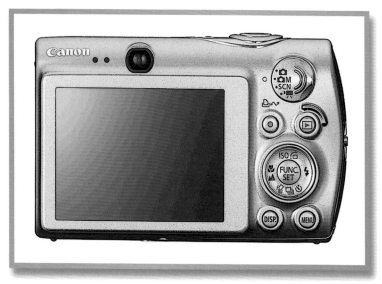

Canon PowerShot SD950 IS compact camera from the back

Next, consider how you're going to view your pictures. If your primary method of sharing is via the computer—email attachments, slide shows, and web pages—your equipment should be new enough to handle the software you want to use with your camera, and it should have the storage available to house the camera's pictures. If you haven't upgraded your computer for three or four years, you may discover that the first accessory you have to buy for your $300 camera is a $1,000 computer.

Many photographers prefer prints and aren't as interested in digital sharing. If you feel the same way, look for a compact camera that makes it easy to connect directly to a printer and produce 4- to 6-inch prints (or larger, if you prefer). You don't need a computer to enjoy digital photography, and there are some great compact printers out there. (For more on painless approaches to printing, see *Chapter 5*.)

Pocket cameras have also become quite adept at capturing video. You may not be using this function right now, but I hope to inspire you to capture movies as well as still photographs. A video clip can be worth a thousand pictures—isn't that how the saying goes? When the best man gives that perfect toast, you want to have your digicam in movie mode. But video capabilities vary greatly from model to model, so this is something to

add to your checklist of features to compare. (For more on how to create movies with your digital camera, see *Chapter 4*.)

You may be wondering, are there any downsides to these pint-size gems? Well, there certainly are a few. Compacts typically have difficulty controlling image noise at ISO 400 and above. Your new point-and-shoot may have a setting for ISO 1600, but you probably won't be satisfied with the resultant pictures. Just because your car's speedometer says 120 mph doesn't mean you should drive that fast.

DEFINITION ▼

Image noise is often referred to as "digital grain." It's a clumpy, sometimes off-colored artifact that invades the otherwise smooth tones of your photographs. Favorite quarters of digital noise include shadow areas and even blue skies.

You'll also have a narrower range of focal lengths available. Most compact zoom lenses provide moderate wide angle to moderate telephoto lengths. And the lens that's mounted on your camera is the lens you're stuck with. This isn't a concern in terms of image quality, only in range. The glass on today's compacts is exceptional and records outstanding images. But if you like super-wide angles or plan to go on safari and photograph wildlife, your compact probably won't provide the optical range you need.

Once you factor in these considerations and decide that a compact is the right camera for you, figure out how much you can spend on your point-and-shoot and then add the cost for a spare battery, memory card, and dedicated printer (if that's how you plan to share your images). Study the following lineup of features to ensure that you buy a camera that has the functions best suited to your shooting style. With a little research, you'll be able to find the right compact for you at a cost you can afford.

Don't forget to spend some time with the owner's manual to become familiar with your camera's unique design and how to use its controls. After that, keep this guide in your accessory bag—not only does it provide a quick reference for the major components, but it will also help you understand how to use those features to take better pictures.

Pros and Cons of a DSLR

Now we get to the big guns. DSLRs provide tremendous flexibility for photographers who need to tackle a wide variety of photo assignments. A key feature is the interchangeable lens. Major camera manufacturers such as Nikon, Canon, Sony, Olympus, Panasonic, and Pentax provide you with dozens of optical choices for your DSLR.

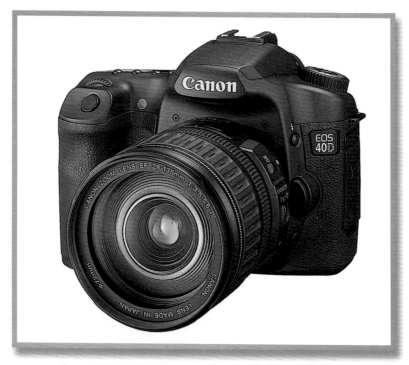

Canon EOS 40D DSLR with interchangeable picture-taking lens

Sports and nature photographers may lean toward powerful zooms that bring the action in close. Special-event shooters will want a high-quality wide-angle lens for working in tight quarters. Portrait photographers need moderate telephotos with wide apertures so that they can soften the background. Regardless of how you want to use your DSLR, there's a perfect lens for you. (OK, well, maybe two or three lenses.)

Before I get into a component-by-component breakdown for all cameras, I'm going to focus on a few of the key features that distinguish DSLRs from other types of cameras. You're probably going to spend more on a DSLR and its accessories, so it's a good idea to understand the basic characteristics of this equipment.

Image Sensors

Instead of film, digital cameras record light with solid-state devices called *image sensors*. If this type of discussion gives you a techno-headache, you can read through my image sensor rule of thumb and skip the rest of the discussion.

TIP ▼

DSLRs have larger image sensors than compact cameras. Larger sensors perform better in low-light conditions. If you like to shoot without a flash indoors, you may want to consider investing in a DSLR.

Larger image sensors (in physical dimensions) generally produce better image quality. That's one of the reasons why DSLRs outperform compacts—they have more real estate to record pixel information. Speaking of pixels, the more megapixels your image sensor supports, the higher the photo's resolution will be, and therefore, the bigger the print it can produce. So, as a rule, 4-megapixel cameras are great for snapshots, but you really need a higher-resolution 8-megapixel or greater sensor for enlargements. With that said, keep in mind that the image sensor is only part of the quality equation. The camera's optics and electronics play major roles too.

If you want to know more about why these rules apply, here's a short course in image sensor technology.

For years, the most common sensors have been charge-coupled devices (CCDs). However, many cameras, such as the Canon and Nikon SLRs, are now employing complementary metal–oxide–semiconductor (CMOS) sensors, which share many of the same attributes of CCD types but use less energy. Another type of sensor, called the Foveon X3, is the current choice for Sigma SLRs. The Foveon sensor has a much different design compared to its CCD and CMOS brethren. It actually uses three separate layers of pixel sensors embedded in silicon, whereas CCD and CMOS sensors have a single layer.

Image sensors also vary in their dimensions. Many entry-level DSLRs use sensors that are referred to as *APS* in size.

Relationship of image sensors: full-size sensor on far left, APS sensor on bottom, and compact camera sensor on top. Photo by Thomas Groliman.

The term *APS* comes from the alternate 24mm film format (Advanced Photo System) that was introduced in the 1990s but never really gained traction. The label survives because many of today's DSLRs have image sensors approximately the same size as an APS film frame (roughly 15mm–23mm). Because the proportions of these APS sensors are smaller than those of 35mm film (24mm–36mm), cameras containing them have increased image magnification when traditional 35mm lenses are mounted on the body. Typically, this increase is around 1.6X.

Some DSLRs employ a four-thirds image sensor. The major proponents of this system are Olympus and Panasonic, but others are part of the consortium, including Fuji and Kodak. The term *four-thirds* refers to the proportions of the image sensor, producing images that are 4:3 in dimension. Current four-thirds sensors by Olympus are approximately 13mm–17mm smaller than APS-size sensors, but are larger than those found in most point-and-shoots. At the other extreme are the pro-level full-frame SLRs with 24mm–36mm sensors (the same dimensions as 35mm film).

Instead of physical size, however, most people refer to image sensors by how many pixels (picture elements) they support. The term *megapixel* means just that: a million pixels. So, instead of saying, "I just bought a camera with a sensor that supports 5 million pixels," you can say, "I just bought a 5-megapixel camera."

Consumer cameras currently range in capacity from 4 to 10 megapixels. Pro cameras have sensors as large as 21 megapixels. Generally speaking, you want at least 4 megapixels for snap-shooting and vacation pictures. The more megapixels your camera has, the bigger the prints you can make. Four-megapixel cameras, for example, can produce quality prints at up to 8 ×10 inches.

Advanced amateurs and pros need more pixel power than vacation shooters. Having an 8-, 12-, or 21-megapixel image provides you with more options when you process the image on the computer and print it out. You can, for example, push the pixels closer together (increasing the "pixels per inch" setting) to create very smooth tones in the photograph, rivaling the images produced by high-quality film cameras.

More pixels also enable you to crop the original photo, maybe choosing just the center portion of the picture, and still have enough image information to make a high-quality enlargement.

A hefty-megapixel image sensor, however, doesn't ensure amazing photo quality. Other aspects of the camera's optics and electronics play important roles too. For example, an 8-megapixel sensor in a compact camera will be in the neighborhood of 7mm–9mm in physical size, but an 8-megapixel sensor in a DSLR will be 15mm–23mm or larger. That means that each of the *photosites* (photosensitive diodes that collect one pixel's worth

of light) on the DSLR's sensor is physically bigger. These bigger photosites collect more light and result in better image quality and reduced digital noise.

In the end, the best way to think about image sensors is the same way you think about the engine in your car: yes, it's vital to the car's performance, but many other factors contribute to a good ride. And don't forget, the driver has something to do with it too.

Optics (Including Stabilized Lenses)

Since you have so many lenses to choose from with a DSLR, where do you start? Regardless of your specialty, all photographers need one or two "bread and butter" optics for everyday use.

The most essential lens is the moderate wide-angle to telephoto zoom. The Nikon VR 24mm–120mm and the Canon IS 17mm–85mm zooms are good examples. They both range from substantial wide angle to moderate telephoto with 5X magnification. Both incorporate image stabilization technologies to reduce the effect of camera shake in low-light conditions. (For an in-depth discussion of different stabilization technologies, see *Image Stabilizer* later in this chapter.) And with either, you can go out for a day of shooting with just that lens and be ready for most situations you'll encounter.

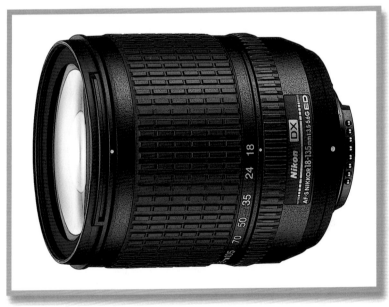

AF-S Nikkor 18-135mm f/3.5–f/5.6 ED zoom lens for Nikon DSLRs

When shopping for a lens for your DSLR, keep in mind that you might have to factor image magnification into the equation. The Canon 40D, for example, has a 1.6X image magnification, which means that a 17–85mm zoom lens will become a 27–136mm lens when mounted on the 40D.

BUYING TIP ▼

The first lens for your DSLR should be one made by the same manufacturer that built your camera. This will help you set the standards for performance and reliability. Down the road, you can experiment with third-party lenses.

Finally, always keep portability in mind when lens shopping. You can spend hundreds or even thousands of dollars on a wide-aperture lens with an impressive zoom range, but if it's too heavy to cart around or it won't fit in your camera bag, you've defeated your primary purpose: to buy a lens that you like to shoot with and will have with you when you need it.

Electronic Flashes

Most compact-camera shooters, and even many advanced amateurs, live and die by the flashes that are built into their cameras. As you get more serious about your photography, you should consider using at least one external flash unit.

The most basic application is mounting a single flash in the hotshoe of your DSLR. (We'll discuss hotshoe in more detail later in this chapter.) This alone will improve your shots, because you will have moved the light source (the flash) farther away from the picture-taking lens. By doing so, you'll reduce the effect of red eye and move unsightly shadows lower behind the subject.

You also have the option of using a dedicated flash cord to extend the distance between the flash and the camera lens. Wedding photographers often use a bracket to position the flash exactly where they want it. The effects of red eye are completely eliminated when using this type of rig.

BUYING TIP ▼

Make sure the external flash you buy is designed to work with your specific camera model. Compatible flash units ensure proper communication between camera and flash, resulting in better pictures.

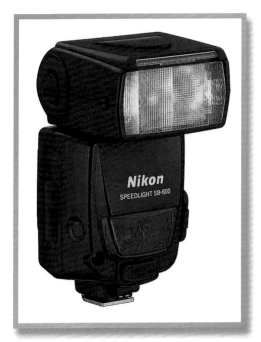

Nikon Speedlight SB-800 external flash

Wireless flash control is a great alternative, especially when you want to use two or more flash units to light a composition. Typically, you mount a wireless controller in the hot-shoe of the camera, and then position your flashes on light stands. When you trip the camera shutter, the wireless controller sends out a signal telling the flash units when to fire and for how long. This amazing system lets you create sophisticated lighting setups without cumbersome wiring.

Many DSLRs include a pop-up flash on the camera body. This function may come in handy in a pinch, but external flash units are an option worth considering if you're serious about this type of photography.

Of course, your typical DSLR kit with a couple of lenses and an external flash is going to cost you at least three times more than a deluxe compact. Certainly cost is a factor.

Making the Decision

Still having a hard time making a decision? Take a look at this basic feature comparison table.

Feature	Compact	DSLR
Removable lens	No	Yes
External flash	No	Yes
Video recording	Yes	No
High-quality enlargements (13×19 upward)	Seldom	Yes
Live preview of image on LCD	Yes	Sometimes
Excellent low-light shooting capability	Seldom	Yes
Shirt pocketability	Often	No
Cost	Less than $400	More than $400

Basic feature comparison

In practical terms, both compacts and DSLRs have their place in the photographer's kit. For your child's soccer game, the proper tool is a DSLR with a telephoto lens. This type of assignment requires camera responsiveness, fast burst rates, extra lens magnification, and good image quality at higher ISO settings.

On the other hand, if you're a guest at a wedding reception, a quality compact makes more sense. You can stash it in your jacket pocket as you interact with others, quickly retrieve it when grab shots present themselves, and even record a short video when the best man makes his toast.

Photography adheres to that old adage, "Use the best tool for the job." If you have the means and desire to own both a quality compact and a DSLR, that is my real-world recommendation. For those who need to choose between the two, I suggest you start with a good compact, and shop for a DSLR as need dictates and finances allow.

A Word About Cameraphones

As popular as compacts and DSLRs are, dozens of other interesting capture devices are available, most with a phone attached. They have their place in the world of photography. And it's worth a brief look to decide how they fit into our overall strategy.

The most notable of the various hybrid devices are cameraphones. Manufacturers of these devices have figured out how to add multimegapixel resolution, digital zoom lenses, and even electronic flashes to the handsets that you once used just to make phone calls. Mobile phones have yet to evolve to the point where they can replace your compact camera, but they are becoming a more tempting alternative for the "camera you always have with you."

Sony Ericsson K850i 5-megapixel cameraphone. Photo by Magnus Palmer.

One of the downsides to cameraphones compared to dedicated compact cameras is the learning curve for managing your pictures once you've captured them. Typically, you don't simply connect the phone to your PC via a Universal Serial Bus (USB) cable and let your computer take it from there (although some models do enable this). Here is an overview of the transfer options most often available with cameraphones:

Removable memory card Devices such as the Palm Treo 680 enable you to write your pictures to a Secure Digital (SD) memory card, remove the card from the device, and then transfer the pictures via a card reader connected to your computer.

Bluetooth wireless Some cameraphones have built-in Bluetooth wireless connectivity that allows you to "send" your pictures to another Bluetooth-enabled device. This could be your computer, another cameraphone, a PDA, or even a Bluetooth printer.

Infrared (IR) transfer IR image transfer works similarly to Bluetooth, but isn't as fast. Again, both devices have to have an IR transceiver to move the pictures. This is an older technology and certainly not worth seeking out.

Email Many cameraphones let you send and receive email. You can attach a picture to an email and send it to your computer.

Multimedia Messaging Service (MMS) MMS is an extension of the text-only Short Messaging Service (SMS) that allows you to send pictures, audio, and even video from your cameraphone. Typically, you'd send these messages to another MMS-enabled phone or to an online service such as Textamerica, where others can log on to see your work.

True, a certain "geek factor" comes with managing images from most cameraphones. But there's no denying the portability of these devices, and handling the pictures they produce is getting easier all the time.

A good example of this evolution is Apple's iPhone introduced during the summer of 2007. This device is more like a mobile computer that can make phone calls and take pictures. iPhone images are easily transferred to your computer when you sync the device, or you can attach its photos to email and send them anywhere in the world. As functionality like this evolves, along with better image quality, cameraphone pictures will become a greater part of our overall image library.

Camera Features from A to Z

The owner's manual that came with your camera does a reasonable job of showing you where its various controls are located. Plus, it's often a good opportunity to learn another language or two. But owner's manuals don't excel at explaining what all of those parts and functions actually do. So, here's where your companion can help you along.

Let's say your camera was a person. Would you take someone you hardly knew to the most exotic corners of the planet? Would you trust this anonymous entity with the memories of your child's first birthday? Heavens no!

So, if you're going to form a partnership with this device, you should at least get to know it. That's what we're going to do right now. Get to know one another.

Then, in Chapter 2, once everyone is on a first-name basis, we'll explore in more detail how we can all work together. But let's save that for a bit later.

AVI

Short for *Audio Video Interleaved*, .avi files are one of the most common formats for storing audio and video captured with a digital camera. Even though AVI is considered a Microsoft Windows format, most variants of it play on Macintosh computers as well. If your digital camera records video, chances are good that you'll see this file designation on your memory card. Other common video formats used on digital cameras include *.mov* (QuickTime movie) and *.mpeg* (Motion Picture Experts Group).

Battery Types

If your camera came with alkaline AA batteries, use them for testing and then replace them as soon as possible with rechargeable nickel-metal hydride (NiMH) batteries, which last much longer than alkalines and will save you lots of money over time. It's always good, however, to keep a fresh set of alkalines handy in case your NiMHs run out of juice while you're away from the charger. Another good practice is to have two sets of the rechargeables, so one's always ready to use. They're a little expensive at first, but much cheaper than buying new alkalines over and over.

Lithium-ions are very popular with major camera makers such as Sony, Nikon, and Canon. Most of these cameras come with their own proprietary battery and its matching charger. Lithium-ions typically have great capacity and hold their charge for a long time, but you might want to buy an extra battery. You can't use readily available alkalines as a backup.

Lithium-ion battery pack for a Nikon D40X DSLR

Another thing to keep an eye out for with lithiums is how you charge the battery. I recommend using a separate charger (the more compact the better), instead of having to recharge the battery by plugging a power adapter into the camera. Obviously, you can't pop in a spare battery and go out and take pictures if you need to plug your camera into a wall socket to recharge.

Color Space

If you stumble across a menu option that requires you to choose between sRGB and Adobe RGB for color space, what do you do? The short answer is, if you're going to be sharing your pictures via a computer (web pages, email, etc.) or sending your images to an online photo service for printing, choose sRGB.

Those of you planning to make fine-art prints on your home printer may consider capturing in Adobe RGB. This color space is a little bigger (with slightly more color variations).

The good news is that no matter what you pick, you can always convert later to the other option.

Computer Connection

The computer connection is used for transferring pictures from camera to computer. Most cameras provide a USB cable to make this connection. USB 2.0 connectors transfer pictures much faster than older USB 1.1 protocols, and are much preferred.

TIP ▼

Connecting your camera directly to the computer is fine, but a better way to go is to use a memory card reader. You can purchase these devices for as little as $20 and they often perform better than cameras connected via cables. Plus, you have the added bonus of not using your digicam's battery juice for transferring images.

Confirmation Lighting

The confirmation light shines when the camera is focused and ready to fire, or when the flash is ready. Blinking indicator lights usually suggest that you need to make an adjustment before taking the picture.

Diopter Adjustment

The diopter adjustment allows for manual adjustment of the optical viewfinder to best suit your vision. When I was younger, I couldn't have cared less about this feature. These days I'm very thankful for it, because it's hard to look through optical viewfinders with glasses on.

Direct Print

Direct Print is a standard developed in 2002 that enables a common printing protocol between camera and printer, eliminating the need for a computer to produce prints. Original adopters were Canon, Epson, Fujifilm, HP, Olympus, and Sony. Many consumer cameras use an evolution of this technology called PictBridge (discussed later).

Display Control

You can turn off the LCD display to conserve battery power. This button often has a third option that provides for the display of camera data on the screen while composing the picture. You can typically cycle through these different settings by pushing the button repeatedly. One useful display option is the live histogram. In this mode, you get a graphical representation of the tonal values in the picture that you're composing, or have just captured, to help you evaluate its exposure. The histogram option is particularly handy when working in bright light that compromises the image on the LCD.

Exposure Metering Options

All digital cameras have some type of exposure meter, but many models have more than one pattern for measuring light. The three most common patterns are:

Center-weighted The meter measures light levels in the entire picture area, with extra emphasis placed on subjects in the center of the frame.

Evaluative The image area is divided into sections (usually six or more), and light is measured in each section. The camera then evaluates each section and matches the overall pattern to data stored in its computer system. The resultant camera settings are determined by how the pattern and data match up.

Spot To determine the exposure, light is measured in only the center of the viewing area, usually indicated by brackets. Everything else is ignored. Spot metering is helpful in contrast lighting situations that might fool other metering patterns.

Advanced cameras may include all three of these metering patterns, whereas more basic models may rely on only the evaluative pattern.

Face Detection

Cameras with face detection activated will identify people in a scene, focus on them, and even adjust the exposure to render them properly. This technology works well and is particularly useful for snap shooters who surrender focusing tasks solely to the camera. Face detection is a big step toward improving the percentage of well-focused, properly exposed candids. It is a top feature to look for in your next compact camera.

Flash

The flash provides additional light for pictures taken indoors or at night, as well as for outdoor portraits. All compact cameras, many DSLRs, and even some cameraphones have built-in flash units. Look for flash controls that are quickly accessible and are not buried deep within a menu system. Why? Because by taking control of your flash by switching it out of Auto mode and to Flash On or Flash Off, you can improve your portraits (as explained in more detail in Chapter 2).

DSLRs also provide the option for mounting external flash units in the *hotshoe* atop the camera. This is an important feature for event photographers because a flash positioned higher above the lens (than built-in flash units) will greatly reduce the chance of red eye appearing in the photographs.

TIP ▼

If you buy an external flash for your camera, get two sets of rechargeable batteries at the same time. Powerful flash units drain batteries quickly, and disposable cells are neither efficient nor environmentally friendly.

Focus Assist Light

The focus assist light helps your camera focus in dim lighting by projecting a white beam, or a subtle pattern, onto the subject. This light may also shine when you're using the red eye reduction flash mode and can serve as the warning light when the self-timer is activated.

Function Button

The function button often serves as a shortcut for important menu items such as ISO and white balance. If you can't find a control in the list of menu items, it's probably here.

Hotshoe

The hotshoe provides a connection for an external flash and other camera accessories. The metal contacts allow the camera to communicate with the flash to provide advanced features such as dedicated exposure control. Often, you can purchase "dedicated flash cords" that enable you to retain communication between camera and flash, but move the two apart for more lighting options. One end of the cord connects to the hotshoe, and the other connects to the base of the flash.

Hotshoe for external flash on Nikon Coolpix P5100

Image Sensor

The image sensor converts light energy passing through the camera lens into a digital signal. Sensor capacity is measured in megapixels. The most common sensors are CCDs. However, many cameras, such as Canon and Nikon SLRs, are now employing CMOS sensors, which share many of the same attributes of CCD types but use less energy. For more details about image sensors, see *Pros and Cons of a DSLR* earlier in this chapter.

TIP ▼

The size of the image sensor is not tied to the number of megapixels your camera records. You can have 12 megapixels of resolution on a compact camera with a small sensor, or 12 megapixels on a larger sensor in a full-frame DSLR. Generally speaking, however, the bigger the image sensor in physical size, the better your camera will perform in low light.

Image Stabilizer

Image stabilization is one of the most important new features added to digital cameras in recent years (along with face detection). This technology helps to offset "soft" pictures resulting from camera shake. When the image stabilizer is on, your pictures are often crisper and show more detail. There are three basic methods for stabilization: optical, sensor, and digital.

Optical image stabilizer (OIS) Used in both compact cameras and DSLRs, this is the most common type of image stabilization. Depending on the camera manufacturer, you'll see different names for this method: Canon calls it Image Stabilization (IS), Nikon refers to it as Vibration Reduction (VR), Panasonic calls it Mega O.I.S., and Sigma labels it Optical Stabilizer (OS).

An OIS uses gyrosensors within the camera or lens to detect shake, and then steadies the path of the image as it makes its way to the sensor. Canon, one of the pioneers of this technology, accomplishes this by using a floating lens element that moves in the opposite direction of the camera shake. If you inadvertently move the camera upward while snapping your shot, the floating lens element adjusts the other way, thereby stabilizing the image as it heads toward the sensor. In DSLRs, motion gyrosensors are located in the lens; in point-and-shoots, they are positioned in the body instead (since there is no room in the lens on these tiny shooters).

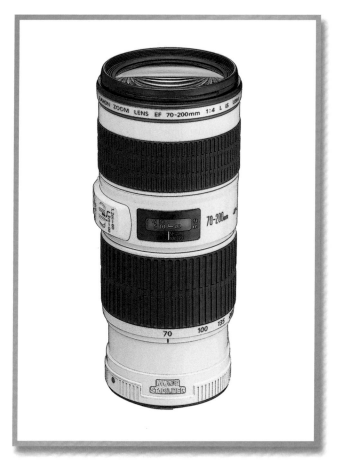

Canon EF 70-200mm f/4 L IS zoom lens

Sensor stabilization Here the camera uses gyrosensors located in the body to detect shake, and then adjusts the actual image sensor (CCD) to counteract the movement. You'll find this method more commonly used in DSLRs, such as Olympus's E-510, Pentax's K100D, and Sony's A100 Alpha. Note that Pentax calls it Shake Reduction, and Sony refers to it as Super SteadyShot. Sensor stabilization does appear in some compact point-and-shoots as well, such as Olympus's Stylus 750.

Digital stabilization Used in compact cameras by companies such as Casio and Olympus, this stabilization method addresses shake by sampling image data and fixing the picture digitally after it's been captured. Unlike optical and sensor

stabilization, which actually correct the image path while you're capturing a picture, digital stabilization attempts to make the picture clearer during the camera's processing stage. This method isn't as viable as OIS and sensor-based stabilization because resultant image quality can be compromised.

When it comes to counteracting camera shake, optical and sensor stabilizers are your best options. The advantage of optical stabilization technology is that you can preview the image in the viewfinder or on the LCD screen, making this method preferable for photographers who want to see the effects of stabilization before snapping a shot.

In terms of dealing with camera shake, both methods are equally effective. If you're buying a compact point-and-shoot camera, you can't go wrong with either. But if you're going the DSLR route, there are a few things to consider. First off, because optical image stabilization takes place within the DSLR's lens, you will have to buy a collection of image stabilization lenses that often cost more than their nonstabilized counterparts. With sensor stabilization, you don't need to invest in any specialized lenses since the camera's doing the stabilizing. However, sensor stabilization does become less effective when you use longer telephoto lenses (300mm and up). If you do a lot of up-close photography, you'll get better results with optical stabilization.

Infrared Sensor

The infrared sensor is primarily used to communicate with the remote control release for cameras that have that capability.

Intelligent ISO

With Intelligent ISO technology, the camera automatically increases the ISO, or light sensitivity setting, when the image sensor detects a moving object. As a result, the camera is able to snap a picture using a faster shutter speed, which freezes the motion of the subject and reduces blur. When the subject stops moving, the camera automatically returns the ISO to a lower setting for better image quality. Panasonic includes Intelligent ISO in many of its cameras, whereas Fuji uses a similar approach called *picture stabilization*.

LCD Monitor

The LCD monitor on the back of your camera has two major jobs to do: composing and reviewing.

Composing pictures The LCD monitor on compact cameras allows for precise framing of the subject, because the image is captured directly through the picture-taking lens. You should always use the LCD monitor in macro mode (for close-ups). Most LCD monitors, however, aren't effective in direct sunlight—the image is hard to see. If you shoot lots of outdoor pictures, make sure your camera has an optical viewfinder as well.

Some DSLRs are now enabling composition via the LCD monitor. Canon's 40D, for example, calls this feature Live View.

Reviewing images The LCD monitor is also used for reviewing pictures you've already captured. Camera manufacturers are now providing models with 2.5-inch (diagonally measured) or bigger LCD viewfinders.

TIP ▼

If you spend more time viewing your images on the camera than on a computer, you should give the size of your camera's LCD monitor important consideration.

Viewfinders That Swivel

Most compacts and DSLRs have LCD viewfinders that are fix-mounted to the back of the camera. But there are advantages to having an LCD monitor that swivels away from the back of the camera. This enables you to hold the camera at a variety of angles and still compose the picture—perfect for taking "over the head" shots at a parade!

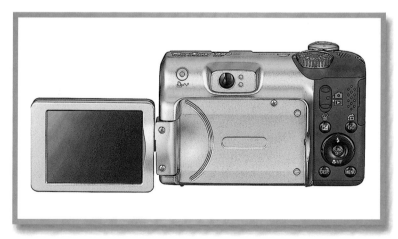

Vari-angle viewfinder on a Canon PowerShot A650 IS compact camera

Memory Cards

Memory cards store the picture data captured by your camera. Nearly every digital camera contains some type of removable memory. When the camera takes a picture and creates the data for that image, it "writes" that information on the memory card. This lets you retrieve or transfer your electronic pictures long after they've been re-corded. This table can help you determine the best memory capacity for your camera, based on its megapixels.

Camera type (megapixels)	4–6 MP	7–10 MP	11 MP and up
Minimum card (megabytes)	512 MB	2 GB	4 GB
Recommended card	2 GB	4 GB	8 GB

Minimum and recommended digicam memory cards

The most popular memory cards are CompactFlash (CF), Secure Digital (SD), and Secure Digital High Capacity (SDHC). But there are others. The Sony Memory Stick (MS), the IBM MicroDrive, the MultimediaCard (MMC), and the xD-Picture Card are available for some cameras. A handful of older cameras use SmartMedia (SM) cards, which are still available but are not as easy to find as they used to be. That technology is being replaced by xD-Picture Cards and SD cards, which are smaller and have more capacity.

The type of memory card your digicam accepts isn't as important as its capacity and performance. Many cameras ship with starter memory cards that hold only 16 MB or 32 MB. These are barely adequate during the learning phase, and once you're ready to take your camera on vacation or photograph your daughter's birthday party, you'll need more memory. Some cameras don't even bundle a memory card. Make sure you have a compatible one on hand, or you'll be sorely disappointed when you take your new camera out of the box.

Another thing to consider when shopping for memory cards is the speed at which they read and write. "High-speed" or "ultra" cards can perform at many times the speed of standard cards, but much of this benefit depends on the sophistication of your camera's electronics, or the speed and compatibility of your memory card reader. If you have a high-performance camera or card reader, you should consider having at least one high-speed memory card. Standard cards should perform just fine for basic models.

TIP ▼

Write your name and phone number on the back of your memory cards (if space allows). That way, if you misplace them, you have a chance of recovering both the cards and the images on them.

Menu Button

The menu button activates the onscreen menu that enables you to set the camera's various functions. Most likely, you'll use the multifunctional jog dial to navigate through those menus.

Microphone Port

The microphone port is the tiny opening on the front of the camera that's used to record audio annotations and add sound to movie clips. Most cameras that have a movie mode have built-in microphones, but not all. Double-check to be sure.

Mode Dial

The mode dial allows you to switch among various picture-taking and picture-reviewing modes. Mode dials are popular with many photographers because all the functions available via the dial are clearly marked on its surface, so you don't have to hunt through menus to make a setting change.

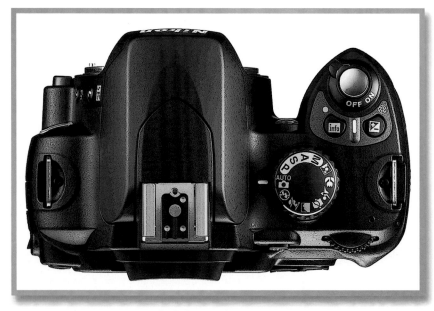

Mode dial on a Nikon D40X DSLR

TIP ▼

Cameras with buttons and dials that give you direct control of most-used functions are easier to use than models that bury vital controls deep within a menu.

Multifunctional Jog Dial

The multifunctional jog dial allows you to navigate through onscreen menus by pressing the four directional buttons. Sometimes jog dial buttons have two sets of functions: one set for changing settings while in picture-taking mode, and the other for making adjustments in picture-viewing mode. Look for little icons next to the jog dial buttons. They usually represent the functions associated with those buttons in picture-taking mode. Here are a few of the most common ones:

Burst This setting lets you take a sequence of shots by holding down the shutter button.

Close-up Sometimes called *macro mode*, this setting allows you to focus your camera on subjects that are only inches away.

Flash modes All digital cameras provide you with flash options, such as Flash On, Flash Off, and red eye reduction. This button allows you to cycle through those options and choose the best one for the situation at hand.

Metering modes Some cameras provide more than one metering mode, such as *Evaluative* and *Spot*. (See *Exposure Metering Options* earlier in this chapter.) You can choose which mode you use via this control.

Self-timer Use this function to delay the shutter from firing for a few seconds after you've pressed the shutter release button.

TIP ▼

Some cameras offer the option of a 2-second or 10-second delay. The shorter delay is useful for night shooting and other situations when the camera is mounted on a tripod and you don't want to jar it at the point of exposure. Ten-second delays are perfect for group shots when the photographer wants to be part of the picture. (Press the shutter button and then make the dash to join the others.)

Optical Viewfinder Lens (On Compact Cameras)

The optical viewfinder lens enables you to compose the picture by looking through the viewfinder lens instead of viewing the LCD monitor on the back of the camera. Using the optical viewfinder saves battery power, but it isn't quite as accurate for framing precise compositions or close-ups.

TIP ▼

More and more compacts, and most cameraphones, eschew the inclusion of optical finders. If you shoot a lot in bright, sunny conditions, you may opt for a camera that has both optical and LCD viewfinders for picture taking.

PictBridge

PictBridge enables direct printing from your digital camera to a printer. You simply view an image on your camera's LCD viewfinder and select Print; then the camera sends the required data to the printer via the USB cable. This eliminates the need for a computer and photo-editing software to produce prints. Both camera and printer must support PictBridge for this to work.

Picture-Taking Lens

The picture-taking lens projects the image you're shooting onto the electronic sensor where the picture is recorded. This lens also captures the image you see on the LCD monitor on the back of the camera.

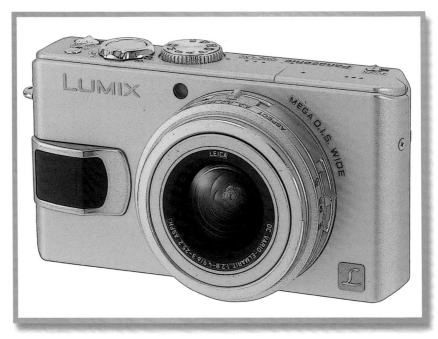

Panasonic LX2 sporting a Leica picture-taking lens

RAM Buffer

The RAM buffer stores image data in the camera's random access memory (RAM) before transferring it to the memory card. The RAM buffer enables advanced functionality, such as Burst and Movie modes. The camera can move picture data to the RAM buffer much faster than it can write data to the memory card. So, when you use Burst mode, for example, the camera captures a sequence of shots in the RAM buffer and then transfers the data to the memory card after you've released the shutter button.

Certain camera models have figured out how to write directly to the memory card. So, if your digicam doesn't have a RAM buffer, don't worry, it's still good.

Remote Release

The remote release allows firing of the camera from distances of up to 15 feet. Some remote releases also allow you to operate the zoom lens. For best results, point the sensor on the remote release at the infrared sensor on the front of the camera.

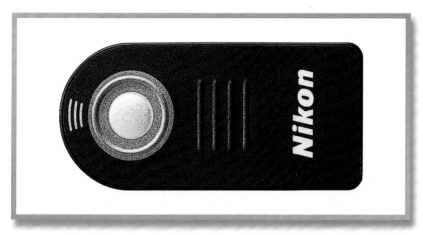

Remote release for a Nikon D40X DSLR

TIP ▼

Remote releases are a great way to trip the shutter without jarring the camera.

Set or Confirmation Button

Press the set or confirmation button to confirm a choice. Most cameras insist that you confirm all selections before enabling them. This button is particularly important when erasing pictures, as it makes it impossible to delete a picture by inadvertently pressing the erase button.

Shutter Button

The shutter button trips the shutter, but it also provides focus and exposure lock. For the best pictures, press lightly on the shutter button and hold it in the halfway position to lock the focus and exposure. Once the confirmation light comes on, you're ready to take the picture. Then add more pressure until the shutter trips. The trick is not to let up on the shutter button once the focus is locked, but to keep the pressure on in the halfway position until the exposure is made. Almost all digital cameras use this type of two-step shutter button.

> **TIP ▼**
>
> A handy tip to ensure that the camera focuses on the area you want is to point the camera directly at what's most important, hold the shutter button down halfway, recompose the picture, and then press the shutter button the rest of the way to make the exposure.

Trash Button

Pressing the trash button removes the current picture displayed on the LCD monitor. This button doesn't usually remove all pictures on a memory card; for that, you have to select the Erase All function via the onscreen menu.

Tripod Socket

The tripod socket allows you to attach the camera to a tripod or flash bracket. Metal sockets are more durable and therefore superior to plastic ones.

USB Mass Storage

USB Mass Storage device connectivity enables the camera to be connected to a computer without using any special drivers, much in the same way that you mount an external hard drive by plugging it in. You can then "drag and drop" your pictures from the camera to the computer, or use an image application to download them.

Digital cameras that are USB Mass Storage devices can be connected to computers running the following operating systems without installing any software: Windows Vista, XP, 2000, ME, and 98 SE, plus Mac OS 9.x and Mac OS X 10.1 or later.

Video Out Connection

The video out connection lets you connect the camera directly to a television or other monitor to display pictures on a larger screen. Using video out is an easy way to show your pictures to a large group of people.

Wi-Fi Image Transfer

Many camera makers are integrating Wi-Fi adapters into their lineups. These adapters allow photographers to send their images via 802.11 wireless networks, eliminating the need to physically connect the camera, or the memory card, to a computer.

Wi-Fi technology has been around for some time and is typically used to enable Internet connectivity in coffee shops, airports, and businesses that have hotspot capability. Soon, sending pictures from your camera might be as easy as sending email from your computer. Kodak and others have already produced consumer cameras with this technology built in, and more are sure to follow.

Wi-Fi Transmitter

Some cameras are offering 802.11 wireless connectivity to other devices, such as the computer, or to services on the Internet. The Nikon Coolpix S51c, for example, allows you to transfer your pictures via Wi-Fi hotspots (locations where wireless networks are available) to online resources such as Flickr's photo-sharing service. Apple's iPhone enables you to attach its pictures and send them via email using Wi-Fi or its cellular network.

The bottom line is that Wi-Fi connectivity frees users from cables and card readers connected to computers, and allows transfer of photos from hotspots all over the world.

Zoom Lenses

Camera makers tend to list two sets of numbers on the barrel of the lens, or on the body near it. The first set is usually followed by "mm" (which stands for millimeter) and looks something like this:

5.4–10.8mm or 7–21mm

These numbers represent the zooming range of your lens. Many consumer digital cameras have a zooming range of 3X, such as a 7–21mm lens.

If you're familiar with 35mm photography, you can translate those digital camera focal lengths into terms that are easier to understand. For example, a 7–21mm zoom lens in the digital world is the rough equivalent of a 35–105mm lens on your traditional SLR.

There is no magic formula you can always apply to translate digital focal lengths to traditional 35mm numbers, though, because the relationship is determined by the size of the camera's sensor. Camera manufacturers will usually tell you what the 35mm equivalent is. Sometimes, as with digital bodies that accept 35mm lenses, they will tell you the size of the sensor and its relationship to your existing lenses. The Canon 40D, for example, has a sensor that's smaller than 35mm film. The result is a focal length factor of 1.6X, so your standard 50mm lens becomes an 80mm telephoto when attached to the 40D.

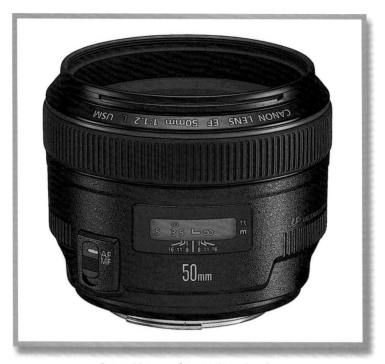

Canon EF 50mm f/1.2 L USM prime lens

A general rule of thumb is that there's a 50% increase from film to digital: a 14mm nominal focal length lens is around 21mm on a DSLR. The exceptions are high-end models such as the Canon EOS 5D, which has a "full-size" sensor (meaning that the lens focal lengths remain the same as in 35mm photography).

The second series of numbers usually looks something like this:

 1:2.8 – 4.0 or 1:2.0 – 2.5

These numbers represent the maximum aperture of the lens at the wide-angle and telephoto settings. Aperture determines the amount of light that can pass through the lens to the camera sensor. Wide apertures, such as 1.8 and 2.0, allow a lot of light to pass through the lens and are therefore better in low-light conditions. Narrower apertures, such as 5.6 and 8, allow less light through the lens and are less desirable for low-light shooting.

When thinking about the best compact or advanced amateur camera for you, keep in mind that you'll have to live with the aperture and zooming range of the lens for the life of the camera. Unlike DSLRs, where you can change the lens, compact cameras have the lens permanently mounted to the body.

Some cameras do provide accessory lenses that mount on the end of the existing glass. These work relatively well, but they are cumbersome and few options are available.

For advanced amateur models, I recommend a zooming range of at least 5X; more is better. Also pay attention to the wide end of the range. Get a lens that gives you the 35mm equivalent of 28mm on the wide end. Digital cameras are notorious for not providing you with as much wide-angle coverage as film cameras.

Advanced amateur cameras provide amazing capabilities in a portable package, and often for less than comparable DSLR kits. If you can live with a lens fixed to the camera body and can sacrifice a bit of high-speed performance, cameras in this class should satisfy the needs of the most critical of photographers.

Zoom/Magnify Lever

Use the zoom/magnify lever to zoom in and out when composing your image in picture-taking mode. (Your camera may have buttons instead, but they work the same way.) When in picture-reviewing mode, this lever also allows you to magnify your image on the LCD monitor for closer inspection.

Putting It All Together

Now that you and your camera are on a first-name basis, how do the two of you take great pictures? In the next chapter, you'll learn helpful techniques such as how to master the focus lock, how to choose the right flash setting, and how to use Burst mode to capture action shots—plus lots more. Great pictures are only a chapter away.

How Does It Work?

TAKING CONTROL OF BUTTONS, DIALS, AND MENUS

By now, you probably understand that a simple flash menu button allows you to cycle through a series of versatile lighting controls. But which one should you choose? In this chapter, you'll learn how to actually use those deceptively simple buttons and dials to tap into the incredible picture-taking capacity hidden within your digital camera.

Hands-On Techniques from A to Z

This chapter covers camera settings and techniques alphabetically from A to Z, or more specifically, from Aperture Value mode to zooming. New terms are listed in italics. If you're not sure where to find any of these settings on your particular camera, double-check the owner's manual and refer to Chapter 1 of this guide.

REMINDER ▼

As always, it's best to have your camera in hand as you work with the text and study the photo examples. The more you shoot, the more natural these techniques will become.

Aperture Value (Av) Mode

Many intermediate and advanced cameras allow you to choose the aperture setting, and the camera sets the proper corresponding shutter speed. This setting is sometimes denoted as *Av*, which stands for *aperture value*. (Some cameras just go with a simple "A" for aperture priority.) You can typically access this setting via the mode dial or as a menu option.

Choose the aperture priority mode when you want to control depth of field. In other words, how much of your picture, from front to back, do you want in focus? Shallow depth of field is often used for portraits—your subject is in focus, but everything else is a little soft. Choose an aperture value of 2.0, 2.8, or 4 for this type of shooting situation. The lower the value, the shallower the depth of field will be, and less of the image will be in focus. This table provides specific depth-of-field settings.

f-stop	Diameter of aperture	Depth of field	Background looks
f/2	Very large	Very shallow	Very soft
f/2.8	Large	Shallow	Soft
f/4	Medium	Moderate	A little out of focus
f/5.6	Medium	Moderate	A little out of focus
f/8	Small	Moderately deep	Mostly in focus
f/11	Small	Deep	Sharp
f/16	Very small	Very deep	Very sharp

Depth-of-field settings

SHOOTING AN OUTDOOR PORTRAIT WITH A SOFT BACKGROUND

If your camera has a portrait-shooting mode, it's designed to open up the aperture to provide a shallow depth of field. Or you can use aperture priority and select f/2, f/2.5, or f/2.8. Place the subject at least 10 feet away from the background, farther if possible. This will soften the background detail, putting more emphasis on your subject. Set your zoom lens to the telephoto position. (This enhances the soft background effect even more.) Focus on the model's eyes. Press the shutter halfway to lock the focus. While still holding the shutter in the halfway position, recompose so that the composition is just the way you want it. Then take the picture. If the lighting on the model's face isn't to your liking, force the flash on (see *Flash Modes* later in this chapter), and shoot again. This setup should provide a nicely focused model against a softened background

This soft background portrait was captured with a Canon Digital Rebel XTi with zoom lens extended to 160mm.

When shooting landscapes, you'll probably want deep depth of field, which produces a sharp image from foreground to background. Choose an aperture value of 8, 11, or 16 for a deeper depth of field.

Autoexposure

See *Programmed Autoexposure* later in this chapter.

Burst/Continuous Shooting Mode

All but the most basic cameras have some sort of burst or continuous shooting mode. The icon looks like layers of rectangles. Typically this mode is a menu option, but some cameras display it as a button option that you can access at any time. Either way, it allows you to shoot a series of pictures while holding the shutter button in the down position. The number of pictures you can record in one burst is determined by the capacity of your camera's internal electronics (either by the capacity of your RAM buffer or by the size of your memory card—for those cameras that just pipe the images right through).

Most people use this continuous shooting feature for recording sports events. It's a great choice for capturing a baseball player's swing or a quarterback's touchdown pass. But Burst mode can also help you compensate for *shutter lag*—that diabolical delay from the moment you press the shutter to when the picture is actually recorded. Some compact digital cameras have shutter lags as long as one second, which is a lifetime in action photography. Higher-end compacts are indeed snappier, whereas most DSLRs have nearly imperceptible lag.

Using Burst mode can help you with all types of cameras. The key is to start the sequence just before the action begins, and then to shoot continuously until the buffer fills up. By doing so, you greatly increase your chances of capturing the decisive moment.

Close-ups

Digital cameras are great for getting in real tight with your subject. This is sometimes referred to as *macro photography*. Unlike most film cameras, digicams usually have the macro capability built right into the camera so you don't need any special accessories for impressive close-ups. Usually, you can access the Macro mode by pressing the button that has the flower icon next to it. Some cameras may bury this option in the onscreen menus and force you to dig a little bit to find it. But keep looking; it's in there somewhere.

USING BURST MODE FOR PORTRAITS

Life's little annoyances can creep into your photography just like they do everywhere else. For example, a sudden puff of breeze can blow hair exactly where you don't want it at the moment of exposure. You can often work around these aggravations by using Burst mode to capture a sequence of shots instead of a single frame.

A series of three images in Burst mode

Put the camera in Burst mode and hold down the shutter button while you monitor the action. In this sequence, for example, a breeze blew a few strands of hair in the model's face just as I captured the first shot. Had I stopped there, I would have missed a good smile. Fortunately, I was in Burst mode, and by the third frame the hair had blown back out of her eyes.

In order to keep everything sharp and in focus, I recommend using the focus lock technique. I start by focusing on the subject's eyes and pressing the shutter button down half way. While still holding the button down half way, recompose the shot, then begin the sequence.

You will have more outtakes using Burst mode. But odds are good that you will also find that magic frame in the sequence that radiates true personality. The only downside is that most flashes can't keep up with Burst modes, so you'll have to use existing light for this technique.

TAKING A CLOSE-UP OF A FLOWER

Put your camera on a tripod. Turn on the close-up mode, and turn off your flash (many digital camera flashes overexpose subjects at very close range). Focus your camera on the most important element in the composition, and hold the shutter halfway down to lock in the focus. While still holding the shutter in the halfway position, recompose if you need to, and then shoot the picture. If there's any type of air movement, wait for a calm moment before shooting and your picture will be sharper. Review your work after a few shots, and then make any necessary adjustments. If you have a manual focus option on your camera, you can compose your picture first, and then manually focus. Use the self-timer or the remote release to trip the shutter. That will prevent you from jarring the camera when you take the shot.

Take a look at the close-up shots of the flower in the following figure. The focus is set to dead center to draw the viewer's eye there. Notice that because of the shallow depth of field, nonprimary elements fall out of focus quickly. This is due to the increased magnification of close-up photography.

Close-up of a Gazania flower by Ruth Cooper

The main thing to remember with close-up photography is that whenever you increase lens magnification, you have to hold the camera extra-steady, as too much camera movement during the exposure can make your picture look out of focus. For important close-ups that you plan to print, you may even want to use a tripod to steady the camera. The rule of thumb is this: *increased magnification means camera shake is also magnified.*

Also, your depth of field is very shallow in close-up photography, so be sure to focus on the element that is most important to you. If you have an aperture priority mode, you can increase the depth of field a little by setting the aperture to f/11, f/16, or f/22. The higher the f-stop setting, the more depth of field you'll have.

Composition (What to Think About While Looking Through the Viewfinder)

Whether you're using the LCD monitor or the optical viewfinder, the composition of your picture determines a large part of its success. *Composition* is the arrangement of the elements in your photograph. The subject, the horizon line, and background elements all play a role in successful composition, and this is just as true with basic point-and-shoot cameras as it is with a top-of-the-line Nikon DSLR.

The first step toward creating great photographs is to consider all the elements in your viewfinder. Here are a few questions to consider when framing your picture: Where is the primary subject placed? Are there any distracting background elements, such as telephone poles? Is the horizon line straight? Should you raise the camera angle, or lower it?

Most photographers keep five rules of thumb in mind when composing their shots. These are not hard and fast rules, but they are worth remembering and applying as often as possible:

Get closer for portraits Use your feet and your zoom lens to frame your subject as tightly as possible. Once you get closer and compose your image, take a few shots and then get closer again. Your pictures will improve dramatically.

Remember the Rule of Thirds Don't always put your subject dead center in the frame. Instead, divide the frame into thirds, both horizontally and vertically (like a tic-tac-toe board), and position the important elements along those lines. Your compositions will be less static and more interesting.

Eliminate busy backgrounds Trees are great, but not when they're growing out of the tops of people's heads. Look out for busy patterns, bright objects, and other distracting elements.

ANALYZING A LANDSCAPE COMPOSITION

When you first look at the following image, you'll most likely find it pleasing, but why? A number of compositional rules are in effect here that contribute to the success of this photograph.

This image seems simple when you first look at it, but many compositional rules are in effect that contribute to its success.

Notice the first place your eye goes to in the image—the gun tower. By placing it in the left third of the composition with a diagonal line leading to it (the fence), you can actually direct the viewer's eye to where you want it to go first. The solid background of trees doesn't distract from the fort, yet it provides some nice color and texture for the shot. Two large eucalyptus trees on either side of the fort serve as a frame to help direct the eye inward. Also notice that the foreground, which is composed to also help pull the viewer's eye inward, is slightly soft. If you prefer a sharper foreground, simply increase your depth of field by choosing an aperture of f/16 or so, and focus on the bend in the fence.

Go high, go low Change your camera angle when working a shot. Get low on the ground and shoot upward. Raise the camera over your head and shoot down—swiveling lenses and LCD monitors make this easier than ever.

Simple is better Try not to clutter your compositions with nonessential elements. Keep things simple, move in close, and find an interesting arrangement.

Compression and Image Quality

Another way in which digital cameras differ from their film counterparts is that they actually let you set the *quality of the image* via the *compression* or *image quality* setting. All digital cameras save images as some form of Joint Photographic Experts Group (JPEG) file. If you've worked with JPEGs, you know that you can save them at various quality levels, usually from 1 to 12. A JPEG saved at level 1 has both very poor quality and a very small file size. It's said to be *highly compressed*. The same file saved at level 12 has excellent image quality, but the corresponding file size is larger. It's *minimally compressed*.

Your digital camera gives you some of these same options in the compression or image quality setting, which is usually one of the first items you'll see when you open the onscreen menu. Instead of providing you with number values such as "3," "6," and "9," cameras use terms such as *basic*, *normal*, and *fine* or *normal*, *fine*, and *superfine*. Regardless of the actual terms used, pay attention to the order in which they are listed.

Basic or normal This is high compression and you should avoid it because it limits your ability to make good prints. Don't be tempted by the number of extra pictures you can squeeze onto a card using high compression. It's much better to buy a bigger memory card instead.

Normal or fine This is medium compression and is acceptable for images you are going to email or post on the Web. You can also make decent prints from images at this setting.

Fine or superfine This is the lowest compression setting on your camera and the one you should consider using all the time. True, you won't be able to squeeze as many pictures onto your memory card as you would using the higher compression settings, but you're capturing images at their highest quality and will always have the option of producing quality prints or large web images from all of your shots.

Compression levels: In this menu the "S" stands for "superfine," which is this camera's highest quality setting.

Some cameras also provide raw or TIFF format options. These settings don't use compression and produce very large files. Raw, in particular, is a good option for photographers wanting to extract the maximum quality from their digital cameras. For more information, see *Work with Raw Files* in Chapter 4.

The rule of thumb, then, is to capture at the highest-quality JPEG settings possible, and consider raw if your camera offers that option and you're willing to process raw files on the computer afterward.

Continuous Shooting Mode

See *Burst/Continuous Shooting Mode* earlier in this chapter.

Deleting Images

See *Erasing Images* later in this chapter.

Digital Zoom

Unlike the optical zoom on your camera, which consists of actual glass elements, the digital zoom is a function of the camera's electronics. By enabling the digital zoom, you can increase the magnification of your lens to bring your subjects even closer than you can with just the optics alone.

The trade-off is that you compromise image quality when you use the digital zoom. Since it's a function of the camera's electronics and not of the actual lens, the digital zoom is really emulating the telephoto effect instead of actually recording the image at that optical magnification. So, even though you get closer by using the digital zoom, there's some quality loss too.

You're usually better off staying within the limits of your optics and then cropping the picture later on your computer. You achieve the same effect of moving in closer, but without the image loss.

> **WARNING ▼**
>
> Don't base a camera-buying decision on the digital zoom rating. Consider only the optical zoom numbers.

DNG

DNG stands for the Digital Negative specification. See *File Formats (Still Images)* later in this chapter.

Drive Modes

Most cameras have at least three settings to choose from when you push the shutter button: single shot, Burst mode, and self-timer. These options are conveniently located under the Drive Mode menu. Since these are handy functions, many cameras make them easily available via a drive mode button instead of burying them deep within the menu system. Typical uses for these options are:

Single shot Makes one exposure each time you press the shutter button. Good for landscape, architecture, close-ups, and other stationary objects.

Burst mode Makes a series of exposures for as long as you hold down the shutter button or until the buffer is full. Handy for sports, action, existing-light portraits, and when you use automatic exposure bracketing.

Self-timer Delays exposure after you've pressed the shutter button for a predeter-mined amount of time, usually 10 seconds. Useful for a photographer joining group shots, timed exposures when the camera is mounted to the tripod, and situations in which you don't want to jar the camera when you trip the shutter.

Erasing Images

There are two ways to erase images. Most photographers use the *single erase* option when they take a bad picture and want to get rid of it to free up space on the memory card. Cameras usually have a trash button for this procedure. The other way to erase is to use the *Erase All* command to wipe every picture off your card, usually after you've

just uploaded them to your computer. The Erase All command is usually a menu item. You can also use the *Format Card* command, but before using either method to wipe clean the memory card, double-check that you have indeed uploaded your pictures to your computer.

As for single erase, sometimes photographers discard images too quickly, before fully examining them. Obviously, some pictures need to go right away. If you're in a dark room and the flash doesn't fire, it's a pretty safe bet that you can dump that shot. But if you take a series of images and want to erase all but the best, make sure you carefully examine the others. Many digital cameras provide a magnify function for the LCD monitor. Try to zoom in on your potential discards, and examine them closely before pressing the trash button. To be extra safe, view them on the computer and then trash them if they still don't make the cut. You can miss subtle details when viewing pictures on the tiny LCD monitor, and sometimes those very details make a great shot.

REMINDER ▼

Never use your computer to erase a memory card. Instead, use the Erase All or Format Card command on your camera. This will ensure the best communication between the memory card and your camera.

So, once you know for sure that you want to remove all the images you have stored on your memory card, which command is better to use: Erase All or Format Card? Generally speaking, you should use Format Card. Doing so cleans up the card's memory and ensures top-notch performance.

Exposure Bracketing (Auto)

When you're not sure which exposure setting is best while working in tricky lighting, you can hedge your bets by using Auto Exposure Bracketing. In this mode, the camera fires a series of shots, usually three, with a different exposure setting for each frame. The sequence is typically in this order: first shot at standard exposure, second underexposed, and third overexposed. You can set the range for the variance between exposures. Most photographers use a 1 f-stop range.

Exposure bracketing is particularly useful when capturing in the JPEG format because exposure adjustments in postproduction are destructive, unless you're using nondestructive software such as Adobe Lightroom or Apple Aperture. (Destructive in this

sense means there is some loss of image quality after you've made the edit and resaved the file.) So, JPEG shooters want to get it right in the camera to curtail image editing later on while working with pictures on the computer. Exposure bracketing increases your odds of getting the perfect exposure with one click of the shutter button. You can discard the outtakes after you've evaluated the images.

A series of three pictures of the same scene at bracketed exposures

Exposure Compensation

One of the most valuable tools available on your digital camera is the exposure compensation scale, which allows you to override your camera's autoexposure reading so that you can capture the image exactly the way you want it. On some cameras, this is a button option that you can get to easily, and on others it's a menu item that's not quite as convenient. Either way, you'll want to know where exposure compensation is on your camera. It can help you take pictures that more accurately represent the scene you're trying to capture and can save you time later when you're adjusting the exposure on your computer.

You may be thinking, "But doesn't my camera always know the right exposure to set?" Not entirely. The light meter in your camera is calibrated to expose properly for anything that's 18% gray. This represents the approximate light reflection of a deep blue sky or green foliage, which are the most common backgrounds in outdoor shots. And indeed, your light meter works great most of the time.

But what if you want to shoot a white statue of St. Francis? It's not 18% gray; it's white! If you don't override your camera's light meter via exposure compensation, your camera will render that statue in 18% gray. In effect, your automatic wonder digicam will *underexpose* your subject.

You can use your camera's exposure compensation option to render the image correctly. When you find the control, you'll see a scale with "0" in the middle, positive numbers to the right, and negative numbers to the left.

CHOOSING EXPOSURE COMPENSATION SETTINGS

I was walking near North Church in Boston one overcast morning and noticed this old statue of St. Francis. Noting the white figure against a relatively dark brick background, I thought this might be a good example for working with exposure compensation.

The white statue is a little dark when shot without exposure compensation.

Adding +2/3 compensation makes the subject brighter.

One full stop of compensation makes it even whiter.

You can see how most cameras would record this first image—the white statue is rendered grayish. In the middle figure, +2/3 exposure compensation has been added, making St. Francis look a little brighter. The last one adds a full stop of compensation.

Which figure is the right one? That depends on your eye.

Most compact cameras will let you preview the effect of exposure compensation live on the LCD screen. So even if you're not sure which way to move the scale, you'll figure it out quickly.

Another option is to exposure lock (shutter down half way) on the more neutral tones of the walkway beneath his feet. Then recompose and take the shot. The camera's metering system does a better job rendering accurate exposures with mid-tones than with stark white or back objects.

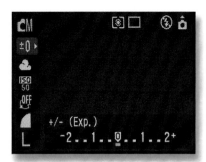

The exposure compensation scale

When you're shooting an object that's very bright, such as a white statue, you may want to *add* more exposure to render it white. So, move the pointer on the exposure scale to +1.

On the other hand, if you're shooting a very dark object with your camera in autoexposure mode, the camera will overexpose the shot and render the object lighter than it really is. If you want to avoid this situation, you should *subtract* exposure by moving the pointer on the exposure scale to −1.

As you become more comfortable with the exposure compensation function, you can make subtler adjustments to your pictures. You can also fine-tune your images later in Photoshop or another image editor, but the more energy you put into capturing your pictures the way you want them in the first place, the less time you'll have to spend processing them later.

Exposure Lock

Typically, when you press the shutter button halfway down and hold it there, the camera locks both the *focus* and the *exposure*. While still holding the button halfway down, you can then recompose the shot and take the picture. But what if you want to lock the focus on one item and the exposure on another element?

Some cameras allow you to lock the exposure independently of the focus. If your camera has this function, it usually works like this: first, you press the shutter button halfway to take a meter reading; while still holding down the shutter button, you then press another button to lock in the exposure. An indicator usually appears on the LCD screen to let you know you've locked the exposure. Now you can focus on another element and take the picture. Remember to turn off the exposure lock once you're done working with that particular shot.

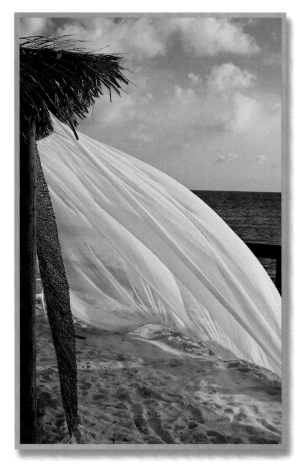

Scenes like this with large, bright areas can sometimes fool your camera's light meter. I metered off a patch of blue sky, locked in the exposure, and then recomposed to get this shot.

Say you want to take a picture of your daughter wearing a white outfit and standing in the sunshine on a bright day. You want the camera to focus on her, but you know that because she's wearing white in the full sun, your digicam will have a hard time getting

the exposure right. The green grass is much closer to the magical 18% gray for which exposure meters are calibrated.

The solution is to lock the focus on your daughter, and then to point the camera at the grass and press the exposure lock button. You've just instructed the camera to focus on one part of the scene and to measure the exposure from another part. The result: a beautiful portrait of your daughter.

You can use exposure lock as a shortcut for exposure compensation. Instead of accessing the exposure scale and adjusting your image that way, you can find a middle tone in the picture you want to shoot, such as a patch of grass, and lock your exposure on it. This is a faster way to override your camera's autoexposure setting in difficult lighting situations.

If you find that you're mostly interested in using exposure lock for people shots, you might want to consider using face detection instead (as covered in this chapter). Not all cameras have face detection, but if yours does, it achieves the same results as focus lock, but more quickly.

Exposure Metering

Most digital cameras rely on *programmed automatic exposure metering* to determine the best aperture and shutter speed for a good exposure. Essentially, the camera's light meter reads the light and compares the data to a set of instructions stored in the camera's memory. The camera then chooses the best aperture/shutter speed combination based on the data it receives from the light meter.

The most important thing you need to know about exposure metering is that cameras are not perfect when it comes to evaluating exposure. They are most often fooled by very bright or very dark subjects.

Fortunately, most cameras allow you to override the programmed exposure setting (see *Exposure Compensation* earlier in this chapter).

Exposure Modes (Basic)

Every time you press the shutter button, two settings need to be determined: aperture and shutter speed. The camera can set these for you; you can set them yourself; or some combination of you and the camera can make the decision. The four basic exposure

modes that represent this combination of aperture and shutter speed are Programmed Automatic, Aperture Priority, Shutter Priority, and Manual.

Programmed Automatic (P) The camera sets both shutter speed and aperture based on its internal light meter reading. Programmed Automatic mode is handy for situations when the photographer wants to concentrate on composition and other aspects of the shot without worrying about exposure settings. This is a good default mode. Many photographers joke that the "P" icon that represents Program mode really stands for Professional mode.

Aperture Priority (Av) You set the aperture (f-stop) and the camera sets the corresponding shutter speed to ensure a good exposure. Aperture Priority is helpful for when you want to control the depth of field (the area that appears in focus from the front to the back of the composition). By opening up the aperture (e.g., f/2.8), you create a relatively shallow depth of field—perfect for portraits with a soft background. When you stop down the aperture (e.g., f/16), you will have greater depth in focus, which is helpful for landscape shooting where you want both that flower in the foreground and the distant mountains in focus.

Shutter Priority (Tv) In this case, you set the shutter speed and the camera sets the corresponding aperture. Shutter priority is used mainly to control movement. If you want to freeze movement, such as a running child or falling drops of water, you would use a fast shutter speed in the neighborhood of 1/500, 1/1,000, or 1/2,000 of a second. If instead you prefer to show movement, such as blurred legs pedaling a bicycle, or soft, angelic flowing water, a slow shutter speed is in order — 1/15, 1/8, or 1/4 of a second.

Manual (M) Some people want to be in control of everything. Manual mode is for them. The photographer sets both the shutter speed and the aperture. The camera provides feedback on its opinion of those settings. Manual mode is sometimes used in advanced flash photography where the photographer wants to capture ambient light and control the exposure on the subject within flash range.

Face Detection

A relatively new technology, face detection can identify human faces in a composition, adjust the camera focus for them, and even ensure that they are properly exposed. You have to activate this function in the menu.

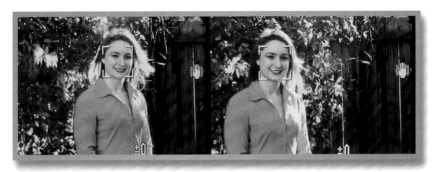

When face detection is activated, the camera will find people regardless of where they are in the frame, and then set the focus and exposure for them.

Face detection is very helpful for events such as birthday parties, wedding receptions, and graduations. It allows you to work quickly and bypass the focus-lock technique that is slower than just composing the scene and letting face detection take it from there. Face detection is very popular on compact cameras, and many DSLRs are beginning to embrace this technology too.

Using face detection couldn't be easier. You turn it on and watch it work its magic as it finds the people in your shot. You may want to hold down the shutter halfway for a second to let the camera lock in, but that's about all you have to do.

File Formats (Still Images)

JPEG is the format most digital cameras use. JPEG files are very portable and nearly every computer and web browser can read them. JPEG files use compression to keep the file size small for easy transport. You can determine the amount of compression by selecting options from the menu function on your digital camera—usually "high," "medium," and "low," but not always using those exact terms. For example, the terms "superfine," "fine," and "normal" are sometimes used instead. See *Compression and Image Quality* earlier in this chapter for more detail about these settings.

Over the past few years, a specialized version of JPEG has emerged for digital camera use. The Exchangeable Image File (EXIF) format has the same compression properties as the standard JPEG file format, but it allows the camera to record to the picture file additional data—such as shutter speed, aperture, and date—that most modern image editors can read. This additional information is sometimes referred to as *metadata*, and it's a real blessing for photographers who like to be able to access the technical specifications for every shot they record, but hate taking notes. The current EXIF version is 2.2.

Tagged Image File Format (TIFF) settings are sometimes available as an alternative high-quality format. TIFFs recorded by digital cameras are not usually compressed, though, so file sizes are very large. For general shooting, using the high quality JPEG setting is just fine. But for those special situations when you want to squeeze every drop of quality from the image, the TIFF setting might be appropriate.

Some camera makers also provide a raw format option that is also uncompressed. As with TIFFs, the file sizes are large, and the quality is very high. Raw is a good choice for the most accurate color fidelity, because you can delay your white balance choice until later, while working on the computer. But keep in mind that the time your camera takes to write information to the memory card might be longer when using this format and your workflow for processing these images may be less streamlined than when handling JPEGs. For more information, see *Work with Raw Files* in Chapter 4.

Adobe's DNG specification is an archival format for digital camera raw data. You can use this format in a couple of ways. You can convert your existing raw files to DNG using a free converter available from Adobe. The DNG file sizes are more compressed (without quality loss), and you'll then have a standard working format for the various raw formats you use.

Some manufacturers, such as Leica and Hasselblad, have adopted DNG as the high-quality format inside the camera too. At this point, it's difficult to say how widespread the DNG format will become, but it's certainly worth keeping an eye on.

This table shows relative sizes of the most common file formats for digital cameras, based on three different resolutions.

Megapixels and resolution	Raw	DNG (no JPEG embedded)	DNG (with large JPEG embedded)	JPEG, high quality	JPEG, normal quality
12.7 MP (4372×2906)	12.1 MB	9.7 MB	11 MB	4.5 MB	2 MB
10 MP (3888×2592)	8.7 MB	7.6 MB	8.7 MB	3.8 MB	1.8 MB
8 MP (3456×2304)	7 MB	6.1 MB	7.1 MB	3.3 MB	1.6 MB

Relative sizes of common file formats

If your camera offers both JPEGs and raw files, when do you choose one over the other, given that you have a memory card large enough to accommodate either? If you have software that you like for processing raw files, I recommend that format for most of your shooting. One exception is an assignment when you need long Burst modes, such as for a sporting event. Then you might consider shooting high-quality JPEGs because they are easier for the camera to process. Also, if you plan to make prints where you insert the memory card directly into an inkjet printer, you'll want JPEGs because those printers can't process and print raw files.

You might also consider capturing in RAW+JPEG. You can print the JPEGs directly with the inkjet printer, and then process the raw files on your computer later. This is something to consider if you have ample memory card space and want to keep all of your options open.

Film Speed

See *ISO Sensitivity* later in this chapter.

Flash Compensation

This feature, more common on advanced amateur cameras than on basic point-and-shoots, enables you to manually adjust the flash exposure. Much in the same way that exposure compensation gives you a tool for fine-tuning your camera's programmed autoexposure, flash compensation provides a way to increase or decrease light output from your flash. So, if your subject is too bright after you take a test shot (i.e., the image is overexposed), you can set flash compensation to −1 to decrease the light output. On the other hand, if your model is rendered too dark in the first shot, you can set flash compensation to +1 to increase the light output.

An easier way to get the same results is to use face detection, if your camera has that capability. It will automatically identify faces in the composition and meter the flash exposure for them.

Flash Modes

The default flash mode for most cameras is automatic, and that's where it stays for most folks. But even the most basic of digicams offers multiple flash settings that can help you take engaging photos under a variety of lighting conditions. Some of the typical flash settings that you might encounter on your camera are:

Auto The camera activates the flash as determined by the light meter reading. If you're indoors in low light, the flash fires. Outside on a bright, sunny day, the camera

turns off the flash. This is a good default mode for your flash, ensuring that you always get some sort of picture in any lighting condition.

Red eye reduction Many digicams have some sort of red eye reduction mode. Red eye occurs when the subject's eyes are dilated (in dim lighting), exposing the blood-filled membrane in the back of the eye. When the light from the flash reflects off this membrane, the resultant color is red. Most cameras tackle this problem by shining a light at the subject before the flash goes off. The preflash causes the pupils to constrict, which may reduce the chance of red eye.

The challenge for a photographer using red eye reduction flash modes is coping with the extended delay from the time the shutter button is pressed until the actual picture is recorded. If you use red eye reduction, remind the subject to hold the pose until the final flash has fired, and remember to hold the camera steady during this entire process.

Auto red eye reduction This is a combination of the auto and red eye reduction modes. The camera uses red eye reduction whenever it determines that flash is required.

Flash On This setting is usually referred to as *fill flash*. The camera will fire the flash with every exposure, regardless of the light meter reading. Flash On is one of the most useful camera settings, because it allows you to take professional-looking portraits outdoors by adding enough light to properly illuminate the subject while balancing the exposure for the background. The result is a beautiful image with all components properly exposed.

A useful application of this technique is to position the subject in open shade, such as beneath a tree, with a nicely illuminated background. Then activate the Flash On setting and stand within range, usually 8 feet. The flash will illuminate the subject and balance the exposure with the background. If your camera has face detection capability, activate it for even better results.

Flash Off Sometimes the flash destroys the mood of a shot. This is particularly true with indoor portraits where the subject is next to a window with daylight streaming in. Creative photographers like to turn off the flash in these settings, steady the camera, and record an *existing-light* photograph that captures the mood of the setting.

Slow-synchro flash Often referred to as *nighttime* mode, this setting tells your camera to use a slow shutter speed in combination with the flash. By doing this, you can capture more background detail in dimly lit scenes, such as portraits shot at twilight, or in an indoor shoot where you want to capture the mood of the setting in addition

to having your main subject properly exposed by the flash. Remember to hold the camera very steady when using slow-synchro flash, to prevent blurring of the background. If you have a tripod, you may want to use it for these types of shots.

Focus Lock

One of the most common pitfalls with point-and-shoot cameras is their tendency to focus on objects other than your intended subject. Instead of capturing your best friend perfectly exposed and in focus, the back wall 10 feet away is sharp as a tack, while your buddy is a fuzzy blob in the foreground. The odds for this scenario increase if your buddy is standing off to one side of the frame.

You can avoid blurring your buddy by using focus lock. Simply point your camera directly at the primary subject, and then press the shutter button halfway until the focus confirmation light goes on. Continue holding the shutter button down in the halfway position and recompose your shot. Then take the picture.

If your camera has face detection capability, you can use it instead of focus lock for people pictures. If you are working with nonhuman main subjects, however, focus lock is still a great way to go.

Format Card

Often included as a menu item, the Format Card command is an alternative to Erase All. Either procedure clears your memory card of all images so that you can shoot more pictures, but Format Card also customizes the memory card to your camera by writing a small amount of data to it. This is a good option to choose before you start to use a new memory card, or if you're swapping in a memory card from another camera. You'll enjoy better performance if you format your memory card using your camera, rather than your computer. Keep in mind, however, that after formatting the card you will need special recovery software to retrieve any accidentally erased images. So, it's best not to format until you're sure all of your pictures are safe and sound (and backed up!).

Image Stabilizer

One of the best new camera technologies, image stabilization, helps to offset blurry pictures resulting from camera shake. As I mentioned in Chapter 1, there are three basic types of stabilization: optical, sensor-based, and digital. The first two are effective and should be on your short list of must-have camera features. The third, digital, doesn't produce results that are as high in quality and isn't a recommended feature. You can read more about all forms of image stabilization in Chapter 1.

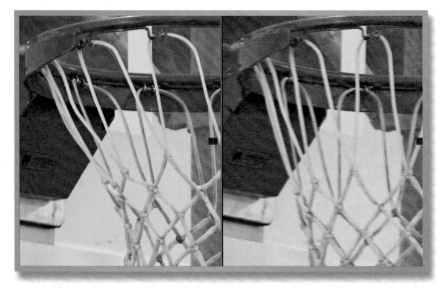

Both of these shots were taken with the same camera at the same shutter speed and f-stop. The photo on the left used Panasonic's Mega O.I.S. image stabilization. The shot on the right is with the same camera, but with O.I.S. turned off.

As for practical application, you'll have up to four modes to choose from on your optical image stabilized camera: Continuous, Shoot Only, Panning, and Off.

Continuous The stabilizer is always on and you can preview its effect on the LCD monitor (compact cameras) or in the optical viewfinder (DSLRs). Continuous mode does use a little more battery power than Shoot Only, but the ability to preview stabilization is more than worth the minor trade-off. Sensor-based stabilizers typically don't offer this mode because stabilization is applied at the sensor and not at the lens.

Shoot Only The stabilizer is activated when you press the shutter button. Your images benefit from stabilization, but you don't get to preview the effect. If your battery is low and you want to milk a few more shots out of it, switching to Shoot Only might help to conserve energy. Both optical and sensor-based stabilizers offer this mode.

Panning Stabilization is applied only to up and down motions. This is useful when you're photographing a moving subject, such as a bicycle rider pedaling by. Panning is a specialized mode that you should use for only these situations. This is typically an optical-based option.

TO FLASH OR NOT TO FLASH

The two most valuable flash modes are Flash On and Flash Off. Yes, auto flash is fine for most situations, but sometimes you have to override auto mode to capture the shot you want. Outdoor portraits, for example, look great when you enable the Flash On mode. The camera will automatically balance the background exposure and supply just the right amount of flash to perfectly illuminate your subject.

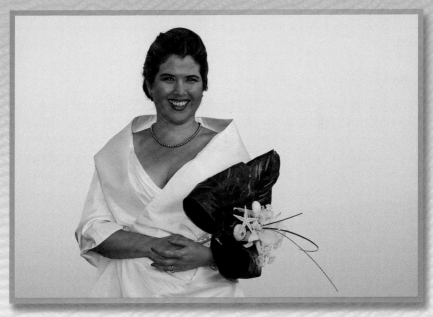

Fill flash used against a bright sky exposes the subject properly.

Notice in this figure how the bride is exposed properly, even though she has a bright sky as the background. If the flash had been left off, the subject would have been severely underexposed because the camera would have been fooled by the bright sky background.

Speaking of backgrounds, if you're stuck with a busy one when trying to isolate the subject, keep in mind that the sky can work great, especially if it's slightly hazy. Just lower your camera angle a bit, turn on the flash, and suddenly mother nature provides you with a wonderful portrait studio.

Off The Off setting disables the stabilizer, which is sometimes appropriate for shots when the camera is supposed to be moving, such as shooting motion shots while riding a bicycle.

TIP ▼

You don't need your image stabilizer on when your camera is mounted on a tripod. Turn it off and conserve a little extra battery power.

As a general rule of thumb, I recommend that you leave the stabilizer on in Continuous or Shoot Only mode to increase your odds of capturing a sharp image in any lighting condition.

Infinity Lock

Some cameras have an *infinity setting* that allows you to lock the focus on subjects that are 10 feet away or farther. At first, this might not seem like an overly useful addition to your camera's feature set, but infinity lock is particularly handy in situations when your camera's autofocus system has difficulty locking in on a subject, causing it to hunt for the correct setting. In this case, you simply select the infinity lock and shoot away.

Infinity lock helps to reduce shutter lag too. If, for example, you're taking pictures at your daughter's soccer game and are missing too many shots because of the lag between the time you press the shutter button and the moment the picture is actually recorded, try using the infinity lock. The camera is now prefocused and will respond more quickly.

Also, if you're shooting landscapes through a car or train window and the camera is having a hard time focusing through the glass, enabling the infinity lock feature should solve your problem.

ISO Sensitivity

Sometimes referred to as film speed, ISO sensitivity is actually a better term for expressing your digital camera's light sensitivity. ISO stands for International Organization for Standardization. This entity has established many standards, including those for light sensitivity of photographic materials.

If your camera has multiple ISO speed settings, you can use these adjustments to increase the light sensitivity of the image sensor. The default setting for most digicams is *ISO 100*. This is the speed setting for general photography. If you're in a low-light situation and need to increase the sensitivity of your image sensor, change the ISO speed setting from 100 to 200, or even 400, if necessary. Each setting is equivalent to one f-stop of light.

Keep your ISO setting at 50, 100, or Auto for general shooting in daylight settings.

Increasing the ISO speed also increases *image noise*, which decreases the quality of your picture. Image noise is more of a problem with compact consumer cameras than with DSLRs. Generally speaking, you can push the ISO setting on a DSLR to 400, 800, or even 1600 and still get excellent quality. For consumer cameras, however, try to keep the setting at 80 or 100, and save the higher ratings for low-light situations where the importance of getting the shot is worth a little extra noise.

You can shoot in dim lighting conditions and not increase your ISO setting beyond 100. (It's true!) Mount the camera on a tripod and trip the shutter with the self-timer. You will record the scene and keep image noise to a minimum. This technique doesn't work for moving subjects because they will blur. But for nightscapes, it's a winner.

REMINDER ▼

If you do increase the ISO speed for a special situation, be sure to change the setting back to 100 immediately after the shoot. You will be sorely disappointed if you photograph a beautiful landscape the next day at ISO 1600.

JPEG

JPEG is an acronym for Joint Photographic Experts Group. See *File Formats (Still Images)* earlier in this chapter.

Macro Mode

See *Close-ups* earlier in this chapter.

Magnify Control

See *Zoom/Magnify Control* later in this chapter.

Manual Exposure Mode

Many compact digital cameras allow only programmed autoexposure, but more advanced models also provide complete control over the aperture and speed settings. If your camera has this option, it's probably denoted as *manual* or *manual exposure mode*.

In traditional film photography, switching to manual mode was a true rite of passage. The photographer would fiddle with the aperture and shutter speed settings, and then hope that the pictures were properly exposed when returned from the photo finisher. This process was by no means for the fainthearted. But digital photography has changed all of that, and because you can preview the final result on the LCD monitor before you press the shutter button, manual mode has become much friendlier. Now manual mode represents both control and convenience.

For outdoor photography, start by setting your shutter speed to 1/125 of a second and the aperture to f/8 (at ISO 100). Preview the scene in your LCD monitor. If the image looks too dark, open up the aperture to f/5.6 or slow down the shutter speed to 1/60 of a second. You'll see the results of your adjustments in real time on the LCD monitor. If the scene is too bright, stop down the aperture to f/11 or speed up the shutter to 1/250 of a second.

This is the beauty of manual mode photography; you have the option of adjusting the aperture and the shutter speed to reach the desired result. Sometimes aperture is more important, such as for portraits in which you want to soften the background. In that case, set the aperture to f/2.0 or f/2.8 (wide open) and change the shutter speed until the image looks correct in the LCD monitor.

At other times, shutter speed might be more important, such as for "stopping the action" during a sporting event: set the shutter speed to 1/500 of a second and adjust the aperture until the image looks properly exposed. Most likely, your camera will also provide you with metering feedback indicating over or underexposure.

With a little practice, you'll find that manual exposure is an easy way for you to be in complete control of your digital camera.

Movie Mode

Compact digital cameras are versatile imaging tools. Many provide the option to capture video (often with sound) as well as still images. Typically, you access this function via the *Movie mode* setting.

Your compact camera can serve double-duty as a capable movie maker. This widescreen video was captured with a Panasonic Lumix LX2 at 30 fps. The video is displayed in QuickTime Player, which is compatible with both Mac and Windows computers.

Less expensive cameras sometimes limit your capture to only a few minutes of video at a time. After it records the sequence, the camera then writes the data to the memory card and allows you to shoot another few minutes, and so on until the memory card is full.

But thanks to improved video *codecs* (short for *compressor/decompressor*), more robust internal electronics, advanced battery technology, and cheaper high-capacity memory cards, many advanced consumer cameras let you record full Standard Definition (SD) (640×480) at full-speed (30 fps) video until the memory card is full. The playback quality still isn't quite as good as the footage you can capture with a dedicated DV camcorder, but it's getting closer to that standard every day. Some digital cameras, often referred to as *hybrid* models, let you shoot for hours instead of minutes if you have a high-speed, big-capacity memory card.

If you have a High Definition (HD) TV, you should consider a digicam that also captures in HD format. Compacts are available that record at 848×480 or even 1280×720. Not only do you get HD resolution, but you get it in a 16:9 aspect ratio that's matched nicely to your HDTV screen. The picture quality is outstanding—so much so that your camcorder may never see the light of day again.

You can preview your movies on the camera's LCD viewfinder, connect the camera to a TV (via supplied cables), or upload the footage to your computer. Most cameras write the movie files in a QuickTime-compatible format, which means that you can play and edit the video on both Windows and Macintosh computers.

TIP ▼

Common movie formats on digital cameras include AVI, MOV, and MPEG-4. Currently, MPEG-4 produces the most compact files, but all of the formats produce high quality. Shop for resolution, aspect ratio, and recording time, and don't worry as much about the file format. Do check, however, that the file format is compatible with your computer and operating system.

For best image quality when shooting video, remember these tips:

Hold the camera steady during filming Tripods are best for video shooting, but in a pinch, you can use your neck strap to stabilize the camera. Hold the camera out from your body until the strap is taut. Keep the camera in this position during filming, and it will help to steady your shots. Also keep an eye out for posts, newspaper stands, fences, and other items on which you can steady your camera. The world can be your tripod, if you're creative.

Turn on the image stabilizer Image stabilization (IS) is just as important in Movie mode as it is for still pictures. If you're holding the camera in your hands during recording, the stabilizer will smooth out those little jitters. IS is not a substitute for good technique, but it does help to steady your shots.

Shoot in good lighting Even more so than still photography, video requires good lighting. If your scene doesn't have enough ambient light, consider adding some with an additional light source. Often, a simple shop light from the hardware store will do the trick.

Frame your subjects tightly Keep in mind that your movies may often be viewed on mobile devices with smaller LCD screens, so you can't afford to stand too far back from the action, or your subjects will be the size of ants. And for those grand productions for screening on HDTVs all over the world, get close and shoot tight.

Your digital camera probably isn't as versatile as a good video camcorder for top-quality recordings. Most digicams don't have ports for external microphones, don't allow zooming during recording, and don't provide as many in-camera effects. On the other hand, you're more likely to have your compact camera with you when life presents those special moments you would otherwise have missed.

MPEG-4 Movie Format

Some hybrid cameras that specialize in recording video as well as still pictures use the MPEG-4 format to compress those movies. MPEG (Moving Picture Experts Group)

compression has been available for years in formats such as MPEG-1, MPEG-2, and now MPEG-4. This technology works its magic by storing only the changes from one frame to another, and not the entire frame itself. This enables much smaller file sizes than uncompressed formats, which is important when you're trying to squeeze full-size video onto a digital camera memory card.

A variation of the MPEG-4 format is H.264, popularized by Apple. This codec delivers such high quality at low data rates (the same quality as MPEG-2 at one-third to one-half the data rate and up to four times the frame size of MPEG-4 at a comparable data rate) that some camera manufacturers are using it for their native movie compression. Casio is among the leaders in this trend, but others are sure to follow. You can play back H.264 movies on both Mac and Windows computers using QuickTime or a QuickTime plug-in.

See *Movie mode* earlier in this chapter for more information about shooting video with your digicam.

TIP ▼

If your camera records in MPEG-4 or H.264 be sure you update the version of Quick-Time on your computer. Most cameras include the latest version on the bundled software disc, or you can download QuickTime for free at *http://www.apple.com*.

Panorama Mode

Have you ever remarked to someone viewing your vacation pictures, "It sure looked a lot more impressive when I was standing there"? If you want to capture the breadth of a scene, you most likely won't be able to fit all the grandeur into your camera's viewfinder—even at the wide-angle setting.

Panorama mode is a clever alternative offered by camera makers to help you capture the grandeur of big landscapes. You work the magic by photographing a sequence of images, and then stitching them together later on your computer. Panorama mode prepares the sequence of shots for easy assemblage. Cameras that have this option also include the corresponding software required to make seamless final images. If your camera didn't come with stitching software, you can use Photoshop Elements, which is a terrific all-purpose image editor that costs less than $100.

Partial Metering Area

See *Spot Meter* later in this chapter.

Photo Effects

Many cameras allow you to apply creative effects—such as B&W, sepia tone, vivid color, and low sharpening—instead of recording standard color images. (You might have to check the owner's manual to see what these are called. Canon, for example, will refer to this function as My Colors.) You can apply those effects when you take the pictures, using the camera's effects settings, or convert your standard color images on your computer after you've uploaded the images—it's your choice. Here are the most common effects modes and what they do (see the practical example for some example photos):

B&W Captures the picture as a grayscale image, eliminating all color.

Blackboard Underexposes the image, ensuring that a blackboard (with chalk writing) will appear black and not gray.

Darker Skin Renders skin tones darker than what the camera would normally record. Helpful for shooting subjects with dark skin because most cameras will render those tones too light.

Lighter Skin Handy setting for fair-skinned subjects which often fool the camera's exposure system into rendering their tones too dark.

Low Sharpening Softens the outlines of the subject. This is a good effect to experiment with for portraits. The effect isn't as strong as with a softening filter that goes over the lens, but this setting is effective.

Positive Film This setting attempts to emulate the saturated colors for which slide film is known. Positive film intensifies colors without rendering them unnatural.

Sepia Tone Adds a warmish brown tone to the image. Unlike B&W, which is easy to apply on a computer, sepia toning is easier to use as an in-camera effect. You might want to take a second shot in full color as a backup.

Vivid Color Enhances the color saturation of the picture. You also can accomplish this easily on a computer later, but this effect is handy because you can use your camera's LCD monitor to preview how a highly saturated image will look. Some cameras offer "vivid" for individual red, green, and blue channels too. Vivid green, for example, would intensify the foliage in a shot with minimal impact on the other colors.

Whiteboard Overexposes the image so that you can use the digital camera to capture notes from a whiteboard or photograph posters with white backgrounds.

Photo Effects Many photographers don't take the time to become familiar with the effects their cameras offer, and therefore miss the opportunity to use them. Take a look at the effects your camera has, and try them out just for the fun of it. Some

you will like and others you will never use. But by knowing the results they produce, you're more likely to take advantage of them in real-world shooting situations. A setting such as Darker Skin can very much improve a portrait and save you postproduction time later on the computer.

Programmed Autoexposure

The most common method for setting the aperture and shutter speed for digital cameras is *programmed autoexposure*. On some basic models, this is the only exposure mode offered.

When using programmed autoexposure, all you have to do is point and shoot. The camera's light meter reads the scene and compares the information gathered to data stored in the camera's electronics. The camera then selects the aperture/shutter speed combination that best matches the information recorded by the light meter.

The caveat is that the camera's electronics can be fooled, resulting in a less-than-perfect picture. See *Exposure Compensation* earlier in this chapter for more information on how to adjust programmed autoexposure to handle tricky lighting situations.

The bottom line is that programmed autoexposure is a reliable tool for capturing good pictures *most* of the time. You can increase your odds by learning a few of the override controls, such as *exposure compensation*, *spot metering*, and *exposure lock*.

I recommend that you use programmed autoexposure as your default setting. That way, you have excellent odds for capturing a quick-grab shot without having to fiddle with the settings. If you use a different mode for a specific purpose, such as aperture priority for a portrait, return the camera to program mode after the shoot so that it's ready to go when that next photo opportunity presents itself.

Many advanced cameras offer both regular Programmed mode (P) and an "auto everything" mode (often denoted by a green rectangle). Both versions use programmed autoexposure, but "auto everything" also controls the flash and other camera functions. Regular Programmed mode just controls the exposure, leaving the other functions to the photographer's discretion.

TIP

If you're just making the transition from a point-and-shoot camera to a DSLR, using the "auto everything" mode will get you off to a fast start. Essentially, your DSLR will behave like your beloved compact. As you get more comfortable, try the "P" mode and experiment with some of the other functions, knowing that your exposures will still be handled by the camera.

TIPS FOR SHOOTING A SUCCESSFUL PANORAMA

Most panoramas require three to six images to achieve the full effect. When looking for good subjects, keep in mind that it's easier to create a seamless image when your subject is evenly illuminated. That usually means the sun is to your back or off one shoulder. Avoid shooting directly into the sun for any of the frames in the sequence, at least until you're a little more experienced. Many photographers switch to Manual mode when recording panorama frames to keep a consistent exposure throughout the image.

The next trick is to keep the horizon line as level as possible when you capture each frame in the sequence. Tripods help tremendously with this task, but you might not always have one with you. The next best solution is to become a *human tripod*. Here's how the technique works:

1. Hold the camera firmly with both hands so that you can see through the optical viewfinder or LCD monitor. Press your elbows against your body to create a steady support for the camera.

2. Compose your first picture, usually starting from the left side. Note the location of the horizon line, and make sure it's level.

This image of a Caribbean sunset consists of three images stitched together using the Photomerge function in Photoshop CS3.

3. Take the first shot. After the shutter has fired, don't move!

4. Continue to hold the camera in the locked-elbow position, and rotate your body a few degrees to the right to compose the next frame in the sequence. The only moving body parts should be your feet—everything else should be still as night. Make sure you have a 30% overlap from the preceding image you shot since the computer uses this overlap information to stitch together the pictures.

5. Check the horizon line to make sure it's in the same location as in the last frame and that it's still level.

6. Take the second shot. (Don't move afterward!) Repeat this procedure through the entire sequence of shots.

7. Turn off Panorama mode once you've finished the series.

With a little practice, you'll be able to employ the human tripod technique to create fantastic panoramas. One last thing to keep in mind is that panoramas are stunning as large prints. Shoot these sequences at your camera's highest resolution so that you always have the option of printing them at maximum size.

Protect Images Command

The Erase All command removes all images from your memory card. It's a handy way to clean house without having to remove each picture individually. What if, however, you wanted to remove all pictures except for one or two? The Protect Images option can help you do just that.

Display the first picture you want to retain on the LCD monitor, and then choose Protect Images from the menu. An icon (such as a key) should appear on the monitor, to indicate that the picture is safe. Repeat for any other images you want to keep, and then use the Erase All command to delete the unprotected images.

Be sure to practice this on test pictures to make sure everything works properly, or try it after you've already downloaded all the pictures you want to keep to your computer. Also, remember that Protect Images doesn't work when you use the Format Card command. With this command, all of your images will be erased, regardless of whether they are protected.

Raw

See *File Formats (Still Images)* earlier in this chapter. (See also *Work with Raw Files* in Chapter 4.)

Resolution

By far one of the most important settings on your camera, resolution sets the pixel dimensions of your picture, thereby determining the size at which the picture can be displayed or printed later on. Most cameras allow you to set the resolution of the picture via the menu options.

If, for example, you select your camera's smallest pixel dimensions—say, 640×480—your picture will be adequate for web page display. But if you wanted to make a photo-quality print of that picture, you would have enough resolution for only a 3×4-inch print at best.

On the other hand, if you select your camera's maximum resolution, such as 2560×1920 pixels (on a 5-megapixel camera), you'll be able to make an 8×10-inch photo-quality print, or even a good 11×14-inch print, from the same picture. (See the table titled *Exposure starting points for sunset and astrophotography** in the Appendix for more details.)

The trade-off is that the higher the resolution is, the more room each picture occupies on your memory card. So, if you have a 5-megapixel camera with a 1 GB memory card, you'll be able to squeeze 461 pictures onto the card when the camera is set to its highest

resolution (2560×1920 pixels). At medium resolution (1600×1200 pixels), your capacity increases to 854 pictures. And at the smallest resolution (640×480 pixels), you can save a whopping 4,721 pictures to your card!

As tempting as 4,721 pictures may sound, remember that if you take that once-in-a-lifetime shot at 640×480, your once-in-a-lifetime print will be wallet-size. On the other hand, if you shoot at 2560×1920, you'll always have the option of making a photo-quality 8×10-inch print, and if you just want to send images via email to friends and family, you can scale down your master image to a smaller resolution before mailing.

REMINDER ▼

For more information on preparing your pictures for email, see *Send Pictures via Email* in Chapter 4.

Self-Timer

The easiest way for you as the photographer to join a group shot is to use your camera's self-timer, which delays the triggering of the shutter (after you press the button) for 10 seconds or so. First, position the camera on a solid surface or on a tripod, and then compose the picture. Before firing away, activate the self-timer. That way, when you press the shutter button, the camera will count to 10 before taking the picture, giving you plenty of time to join your friends. The self-timer is also valuable anytime you want to shoot with minimum vibration to the camera. Set the camera on a steady surface, press the shutter button, and when the exposure is made seconds later, it will be free from the effects of camera shake.

One of the tricks to self-timer mastery is to make sure the camera's focusing sensor is reading the subjects and not the background. Be especially careful when using the self-timer for portraits of couples, because the sensor often reads the area right between their heads. If your camera has face detection, you might want to use it. If not, you can try focus lock or manual focus if your camera offers this option. When all else fails, simply make sure that your subjects are in the center of the frame and close together. This might not be the most artful composition, but at least everyone will be in focus.

Sequence Shooting

See *Burst/Continuous Shooting Mode* earlier in this chapter.

Shutter Priority Mode

See *Timed Value (Tv) Mode* later in this chapter.

IMAGE EFFECTS WITHOUT THE SOFTWARE INVESTMENT

You can employ photo effects without waiting to get back to your computer. The first image here was captured in standard color mode.

Standard color mode

But you can take the same picture with a completely different look, using a B&W effect, for instance, as shown in the top image on the opposite page. You can even shoot in sepia, as illustrated in the image below.

By the way, a handy use for B&W effect is to preview how a picture will look. After you've had a peek on your LCD, I recommend that you capture the photo in color and then convert it to B&W on your computer if you have that option. That way you have both versions of the image.

If you're really feeling playful, you can try some of the other in-camera effects that we often see in camera menus, such as vivid, neutral, positive film (otherwise known as transparencies), lighter skin tone, darker skin tone, and a host of others.

Remember that if you're shooting JPEGs, this will be the final image that's uploaded to your computer. But if you're lucky enough to have a RAW+JPEG mode, the JPEG will show the effect, and the RAW will have full image information. It's the best of both worlds.

The B&W effect

The sepia tone effect

USING THE SELF-TIMER FOR CAPTURING STRIKING NIGHT SHOTS

You also can use the self-timer as a substitute for a remote (or cable) release. This comes in handy for pictures that require the shutter to be open for a long time, such as a nighttime shot when the camera is on a tripod.

Las Vegas is much more interesting at night. This shot was captured by steadying the camera and using the self-timer to trip the shutter without vibrating it.

By using the self-timer or remote release, you can trip the shutter without vibrating the camera. Some cameras make this even easier by providing you with a two-second option to complement the standard 10-second delay. That way, you don't have to wait nearly as long for the shutter to trip once you've activated the timer. This technique made this nighttime shot possible.

Spot Meter

The spot meter pattern enables you to read the exposure for a small area or spot in the viewfinder, usually 5% or less of the center of the frame. Not all cameras include a spot meter option, but those that do allow the photographer to set the exposure on an element in the composition rather than on the scene as a whole.

The most practical method for spot metering is to point the metering area at the object in the scene that is most important to you, and then to use exposure lock. You can then recompose the scene in any way you want, knowing that the most important element in the picture will be exposed properly.

Some cameras have *partial metering* instead of a true spot meter. Partial metering behaves the same way as a spot meter, but the metering area is bigger. Spot meters usually read 5% or less of the viewfinder, whereas partial metering patterns typically read about 10%.

TIFF

TIFF is the acronym for Tagged Image File Format. See *File Formats (Still Images)* earlier in this chapter.

Timed Value (Tv) Mode

Often referred to as *shutter priority*, this setting is commonly available on advanced amateur and pro-level cameras. This setting is designated by Tv or sometimes simply "T" or "S". Tv enables you to set the shutter speed and lets the camera figure out the corresponding aperture setting. A common use for Tv is for sports photography, in which the action is frozen with a fast shutter speed.

Tv is also useful for situations that demand a very slow shutter speed, such as to create a soft, dreamlike effect with running water. Here are a few scenarios where you might want to switch to Tv mode:

Sports events A fast shutter speed of 1/500 or 1/1,000 of a second will "stop the action." You'll need plenty of ambient light to use these settings. In a pinch, you can increase your ISO speed setting to 400 to make your camera more light-sensitive, but remember that you'll also gain image noise as part of the bargain.

Children playing outdoors A fast shutter speed of 1/250 or 1/500 of a second will help you record children at play. If you feel like you're missing good shots because of shutter lag (delay from the moment you press the shutter to when the picture is actually recorded), try using *focus lock* to shorten lag time. You may also want to

turn on the fill flash (see *Flash Modes* earlier in this chapter) and stay within 10 feet of your subjects. In addition to improving the lighting for outdoor portraits, the flash helps to freeze the action.

Running water The effect you want determines the shutter speed you choose. If you want to freeze the water and see droplets suspended in air, use a fast shutter speed such as 1/250 or 1/500 of a second. If you're shooting a waterfall and want a soft, dreamlike effect, select a slow shutter speed, such as 1/8 of a second. In this case, make sure you have your camera securely mounted on a tripod.

TIP ▼

If the scene is too bright for you to use a slow shutter speed, hold your sunglasses over the lens while making the exposure. Not only will this create a longer exposure, but you'll also get a nice polarizing effect as a bonus! (I describe this in more detail in Chapter 3, in the aptly-named section, *Use Sunglasses as a Polarizing Filter*. If your camera does accept accessory filters, one of the best to have in your kit is a polarizer, which is much easier to use than holding sunglasses over the lens.

Streaking lights To show motion, use a very slow shutter speed, such as two, four, or even eight seconds (if your camera provides those options). This method is particularly effective at twilight to capture cars' lights as they drive by. Again, mounting your camera on a tripod is essential. If you have a remote release, you might want to use it to prevent you from jarring the camera as you trip the shutter.

These examples don't cover every situation, but they will help you to use shutter priority to create the effect you want when working with subjects in motion.

White Balance

Different light sources, such as tungsten light bulbs, produce light at different color temperatures than normal daylight (different temperatures often result in pictures that are cooler or bluish in some situations, or warmer or reddish in others). You might not always notice these subtle shifts because your optical/nervous system compensates for these variations in color. Unfortunately, cameras need a little more help as you move from outdoors to indoors.

DREAMLIKE WATER SHOTS

The dreamlike quality of the running water in these images was captured with the timed value mode setting. By using a slow shutter speed (four seconds), I was able to soften the appearance of the falling water. A tripod and a bit of patience are necessary to capture this type of shot. For the summertime water play, I used a much faster shutter speed, 1/250, to freeze the motion of water.

A slow shutter speed resulting in a long exposure can make for magical shots of waterfalls...

...and fast shutter speeds can freeze water in mid-play!

Film cameras rely on color correction filters to capture natural tones under a variety of conditions. Digital cameras make things easier by providing a built-in *white balance* adjustment. This control not only allows you to capture pictures with accurate tones, but also lets you preview the effect on your LCD monitor before you take the shot. Think of the white balance control as your own personal filter collection, built right into the camera.

The default setting for your camera is *auto white balance*. This mode works amazingly well most of the time. To test it, point the camera at a different light source, such as a regular light bulb, and watch in the LCD monitor as the image slowly goes from very amber to a less surreal off-white.

Still, the effect produced by auto white balance may not always be exactly what you're looking for. In these instances, you can override the auto mode via one of the color correction presets available on your camera. Here's a list of the most common ones:

Daylight (slight warming) Used for general outdoor photography. Adds slight warmth to the coloring to offset a blue, cloudless sky.

Cloudy (moderate warming) Helps to correct overcast skies, but is also good for shooting in open shade, such as under a tree. This setting adds more warmth to the scene than the Daylight selection.

Shade (strong warming) Of the three warming options, Shade produces the most noticeable effect. I often think it's a bit too orange for my taste, and I prefer the Cloudy setting. Let your eyes be your guide.

Tungsten (cooling effect) Adds a bluish tone to offset the reddish cast created by standard light bulbs.

Fluorescent (compensates for standard bulbs) Corrects for the greenish cast under warm-white or cool-white fluorescent tubes.

Fluorescent H (compensates for daylight balanced bulbs) Helps to balance the color for daylight fluorescent tubes.

Here's a typical white balance menu. The Cloudy white balance setting warms (adds red/yellow to) the tones in the picture. The Tungsten setting (represented by the light bulb to the right of Cloudy) cools (adds blue to) image tones.

Typical white balance menu set to Cloudy

Many intermediate to advanced cameras also include a custom white balance that allows the camera to find the right color correction when you point it at a white surface. Even better, some advanced DSLRs, such as the Canon 40D, let you select specific hues via the Kelvin color temperature scale. If your camera has this capability, be sure to see the table titled *Number of pictures to capacity of memory card reference** in the Appendix for a complete listing of Kelvin degrees and their corresponding light sources.

One final thought on white balance: if you use the raw format when capturing images, you can stick with the auto white balance setting and then fine-tune the color temperature later on your computer with the raw image editor. I do not recommend this technique as your default approach, but it is helpful in tricky lighting situations when you're having a hard time determining the right camera setting.

Zoom/Magnify Control

Most people are familiar with using the zoom lever (or buttons) to zoom in and out when composing images in picture-taking mode. But magnifying the picture you just captured on the LCD monitor for closer inspection is equally valuable.

The problem with LCD monitors is that they are very small, colorful, and sharp. What's wrong with that? If you don't "zoom in" when you review your pictures on these little screens, you might be misled as to the quality of your shots. In other words, LCD monitors make your pictures look better than they really are (conversely, you may miss small details that make one shot better than the next).

By using the magnify control to zoom in on your subject as you review a picture, you can get a better idea of its true quality. For example, you may want to take a closer look at the subject's face on the LCD monitor after you've shot a portrait. If you don't zoom in to check out the image, when you upload it to your computer you may find (much

to your dismay) that the subject's eyes were closed. If you had used the magnify control right after you had taken the shot, you might have seen the closed eyes and continued the shoot.

Obviously, you don't want to employ the magnify control after every shot you take, or people will lose patience with you. But before you let your subject leave, take a few moments to review a sampling of the images so that you know you won't be disappointed when you get home and upload the pictures.

Putting It All Together

By now, you've committed everything you learned in this chapter to memory, right? Well, probably not. That's why this book is your companion and not a desktop reference. Keep it with you as you work your magic.

Over time, you'll begin to use many of these functions in combination with one another to achieve the effect you want. For example, one day you may use both the white balance and exposure compensation adjustments to create a dark, moody indoor portrait. The next day you may use the fill flash mode and aperture priority to shoot stunning bridal portraits at a wedding.

One of the great advantages of digital photography is that you can experiment with these settings, and it doesn't cost you a penny. Plus, you get immediate feedback from your efforts.

In Chapter 3, you'll start to put your camera knowledge to use as you learn many of the techniques that pros use to create great images. So, recharge those batteries, and let's get to it.

How to Shoot Like a Pro

ADVICE FOR REAL-LIFE SCENARIOS

By now, you and your digital camera have become fast friends and are working together to make great images. But as with the art of cooking and life, there's always more to learn. This chapter is more conversational than the previous two. The earlier chapters of the book were designed for quick reference—to use while standing on the battlefield of photography and trying to survive. But now the discussion becomes more free-flowing, like a conversation between two photographers trying to decide the best approach for a given situation. So, grab a fresh memory card and a charged set of batteries, and prepare for the next stage of your journey.

How do I...? Those are the first three words in any photography question, aren't they? Most of the time you know what you want to do: capture that sunset; take a pretty portrait; preserve the memory of that monument. The trick is to know how to see the world the way your camera does.

This is such an important point that I'm going to tell you a story about my evolution as a photographer. Back in the slide film days, I struggled with getting the exposure right. My slides rarely turned out as I remembered the scenes. My pictures were always too light or too dark.

I went to a talk by noted wildlife photographer Galen Rowell to learn whatever I could about how he captured those beautiful pictures I had seen in magazines. At one point he stopped, then remarked, "The trick is to know how to see the world the way film does."

Once I realized that my eyes can distinguish about twice as much dynamic range as film can, I was on my way to taking better pictures. The funny thing is, all these years later, the notion still applies. Except now we're using image sensors instead of film.

And that brings me back to what you're going to learn here: how to see the world through the lens of your camera, and then capture the parts of it that are important to you. I won't be covering every conceivable situation in this chapter, but if you master these techniques, few pictures will get by your poised shutter finger. And when your friends mutter something like "How do I take pictures of those clouds outside the airplane window?" you can reply, "Oh, that's easy. Just put the edge of the lens barrel against the glass to minimize reflections, and then turn off the flash."

First Steps

Regardless of whether you're striving to become a master chef or a successful photographer, learning the basics of your craft will help you succeed. In this section, you'll build a framework of working knowledge. Then, we'll gain speed and move into some fun power tips.

Take Portraits Your Subjects Will Love

When most folks think of portrait photography, they envision studio lighting, canvas backdrops, and a camera perched upon a tripod. But many photographers don't have access to lavish professional studios and, honestly, it's not necessary for dynamite portraits.

All you really need is a willing subject, a decent outdoor setting (preferably with trees), and your digital camera, and you can be on your way to creating outstanding images.

First, start with these magic rules for great outdoor portraits:

Try to add supplemental light from the flash or a reflector Turning on the flash outdoors is a trick that wedding photographers have been using for years. If you really want to impress your subjects, position them in the open shade (such as under a tree) with a nice background in the distance. An overcast day works well too. Then turn on the fill flash and make sure you're standing within 10 feet (so that the flash can reach the subjects). The camera will balance the amount of light from the flash with the natural background illumination, resulting in an evenly exposed portrait. A variation on this technique is to turn off the flash and use a reflector to bounce the light back toward the subjects' faces. The advantage here is that the reflected light is softer than that from a fill flash.

After placing the subjects in open shade, fill flash was used to brighten their features.

Learn to love high clouds and overcast days High clouds turn the entire sky into a giant lighting softbox, and all of nature becomes your portrait studio. The diffused lighting is perfect for outdoor portraits, and it softens skin tones. In this situation, you have the option of shooting without a flash and reflectors. If you want to brighten up your model's eyes a bit, you can turn on the fill flash. One thing to remember when shooting in this type of lighting is to change your white balance to Cloudy, or the skin tones may be too cool (bluish).

TIP ▼

Cloudy or not cloudy—which is better? Outdoor portraits and group shots benefit from high clouds that diffuse the light. But for landscapes, the lack of color in the sky makes it difficult to capture those big captivating scenes. So, when it's overcast, shoot portraits and close-ups, and when you have those big booming skies, take advantage and capture inspiring landscapes.

Get close and experiment with angles The tighter you frame the shot, the more impact it will have. Extend your zoom lens and move your feet to create more powerful images. Once you've moved in close and have shot a series of images, get closer and shoot again. I captured this shot on about the sixth frame, just as the model had begun to relax.

Once you've found a setting that you like and you have everything in order, you can begin to "work the scene." Start by taking a few straightforward shots. Pay close attention while you have the model turn a little to the left, then to the right. When you see a position you like, shoot a few frames. (Don't get too carried away with this "working the angles" thing, or people will hate you. You're not a swimsuit photographer on a *Sports Illustrated* location shoot. The point is, don't be afraid to experiment with different camera positions. Just do it quickly.)

Next, move in closer and work a few more angles. Raise the camera and have the model look upward; lower the camera and have the subject look away. Be sure to take lots of shots while experimenting with angles, because once you've finished shooting and have a chance to review the images on your computer screen, you'll end up discarding many images that may have looked great on the camera's LCD monitor. When they're enlarged, you'll see bothersome imperfections you didn't notice before.

As you continue to shoot during the portrait session, move in closer for tighter compositions. Models typically relax as the shoot progresses, enabling you to capture more natural facial expressions.

When shooting portraits, communicate with your subjects and try to put them at ease. Nobody likes the silent treatment from the photographer. It makes your subjects feel like you're unhappy with how the shoot is going.

Here are a few other things to avoid when shooting outdoor portraits:

Avoid harsh side lighting on faces Light coming in from the side accentuates texture. That's the last thing most models want to see in their shots, because more texture equates to increased visibility of aging skin or imperfections. Use a fill flash or reflector to minimize texture, and avoid side lighting unless for special effect.

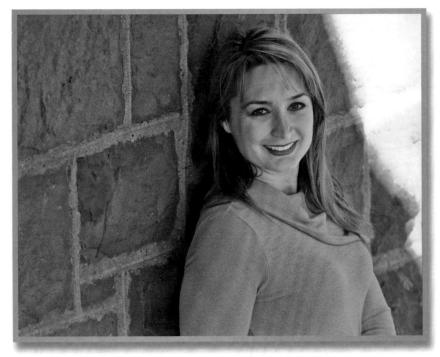

The lighting this day was harsh, as you can tell by the bright band on the right side of the composition. By moving the subject out of the harsh light, I was able to capture a flattering, relaxed portrait.

Keep them off balance Most people stand very flat-footed during portrait sessions. Have your models shift their weight to one foot or the other. Have them arch their back or move their hips. By getting them slightly off balance, you'll find interesting poses that add energy to the session.

Avoid skimping on time or the number of frames you shoot Your images may look good on that little 2.5-inch LCD monitor, but when you blow them up on the computer screen, you're going to see lots of things you don't like. Take many shots of each pose, and if you're lucky you'll end up with a few you really like.

Don't torture models by making them look into the sun Yes, you were told for years to shoot with the sun to your back—but the photographer, not the model, devised that rule. Blasting your subjects' retinas with direct sunlight is only going to make them squint, sweat, and maybe swear. Be kind to your models, and they'll reward you with great shots.

Avoid busy backgrounds Bright colors, linear patterns, and chaotic landscape elements will detract from your compositions. Look for continuous tones without the hum of distracting elements.

Be nice That's right, you heard me correctly: be nice to your models. They're already putting their self-confidence on the line by letting you take their picture. Don't make them regret that decision. When shoots go well, credit goes to the models. When shoots go badly, it's the photographer's fault. Keep your ego in check so that theirs can stay intact.

Now that we've covered the basics, here are a couple of super pro tips. Make sure you have some good, solid shots recorded on your memory card before you start to experiment with these techniques. Once you do, try these suggestions:

Soft backgrounds These are simply lovely. A soft, slightly out-of-focus background keeps the viewer's eye on the model and gives your shots a real professional look. I described the mechanics of this technique in Chapter 2, in *Aperture Value (Av) Mode*.

A portrait with a soft background keeps the eye on the model.

Rim lighting When you place the sun behind the model, often you get highlights along the hair. Certain hairstyles really accentuate this effect. Remember to use fill flash for this setup, or your model's face will be underexposed.

Set Up Group Shots

Many of the rules for engaging portraits apply to group shots too, so keep in mind everything you've learned so far while preparing for this assignment.

The first challenge is to arrange the group into a decent composition. If you've ever participated in a wedding, you know this drill. Avoid, if possible, having all of the heads in a straight line. This creates a static composition. Also resist the urge to center all of the subjects in the middle of the frame. You can create a little compositional dynamism by working the Rule of Thirds. See *Composition (What to Think About While Looking Through the Viewfinder)* in Chapter 2.

Remind everyone in the shot that they need to have a clear view of the camera. If they can't see the camera, the camera won't be able to see them. Next, position the people as close together as possible. Group-shot participants tend to stand too far apart. That might look OK in real life, but the camera accentuates the distance between people and the result looks awkward. Plus, you can't afford to have the shot span the width of a football field, or you'll never see people's faces unless you enlarge the image to poster size.

Remember to take lots of shots—for large groups, a minimum of five frames for each composition. This gives you a chance to overcome blinking eyes, sudden head turns, bad smiles, and unexpected gusts of wind ruining your pictures.

Before pressing the shutter button, quickly scan the group and look for little annoyances that will drive you crazy later: crooked ties, sloppy hair, and turned-up collars will make you insane during postproduction.

TIP ▼

Carry a stepladder for big group shots. When shooting groups of 10 or more, it's best to position your subjects on steps so that you can stagger their heights and compose a more compact shot. But if steps aren't available, you can climb a few rungs on a portable ladder. Elevating the camera gives you a better chance of capturing a clean shot of everyone's face.

Group shots should not look like police lineups. Look for a pretty setting, and think creatively as you position your subjects. Once you have the "safe shot," go for something a bit more fun. Often, these end up being the favorites.

Finally, work quickly. You're not Martin Scorsese making the great American epic, so don't act like you are. Keep things moving for the sake of your subjects (and for your own tired feet!).

Take Passport Photos and Self-Portraits

Some people may think that a photographer who turns the camera toward himself exemplifies the height of narcissism, but sometimes you need a shot and no one is around to take it for you. Headshots for passport photos and personal websites are typical scenarios for the emergency self-portrait. Start with the basics: make sure your hair is combed, your collar is down, your shirt is clean, and your teeth are free of spinach (and lipstick!).

Then find a location with a pleasing, uncluttered background. Put the camera on a tripod, and set it to focus on the area where you'll be standing or sitting. Activate the self-timer.

If the room is too dim for an existing-light portrait, try using a slow-synchro flash (see *Flash Modes* in Chapter 2 for more information). This type of flash provides enough illumination for a good portrait, but slows down the shutter enough to record the ambient light in the room.

Now position yourself where you focused the camera, and look directly into the lens. Don't forget to smile, or at least not to grimace. (Remember, you want governments to let you into their country.)

REMINDER ▼

Passport photos need to be cropped to 2×2 inches, with a .5-inch space between the top of the head and the top edge of the photograph. The head needs to be facing the camera squarely, with a good view of the eyes and no distinct shadows covering the face. The background must be white or off-white and the image must be printed on high-quality photo paper.

Take several shots, trying different poses until you hit on a few you like. If you have a remote release for your camera, you can save yourself lots of running back and forth from the tripod to the modeling position.

TIP ▼

Position a mirror behind the camera so that you can better pose yourself at the moment of exposure.

Self-portraits are perfect for experimenting with different looks because you might feel more self-conscious about when someone else is behind the camera. You can try different expressions and poses and erase the bad ones, and the world will never know the difference.

Take Interesting Kid Shots

Children are a challenge for many consumer digital cameras, primarily because of shutter lag. In short, kids move faster than some digicams can react. But with a few adjustments, you can capture excellent images regardless of the type of camera you have.

One of the most important adjustments is to get down to kid level when shooting. This is hands and knees photography at its best. If you need to, get on your belly for just the right angle. Getting down to their level will instantly make your shots more engaging.

Next, get close. Then get closer. This may seem impossible at times with subjects who move so fast, but if you want great shots, you've got to keep your subjects within range.

Now turn on the flash, regardless of whether you're indoors or out. Not only will this provide even illumination, but the flash helps to freeze action, and you'll need all the help you can get in this category. Keep in mind, however, that the flash range of most digicams ends at around 8 feet.

Finally, use the focus lock technique described under the aptly named *Focus Lock* section in Chapter 2. By doing so, you can reduce shutter lag and increase your percentage of good shots.

Some of the most rewarding pictures you'll ever record will be of children. Like the child-rearing process itself, kid photography requires patience—but the results can far surpass the effort.

Get close and get low for effective kid shots. Photo by Paige Green.

Create Powerful Landscape Images

You could spend your entire lifetime studying how to make great landscape images. There are, however, a few key techniques that will improve your nature shots right away while you learn the subtleties of the craft. Keep these few tips in the back of your mind while shooting.

Work with "magic light" Landscape pictures shot *two hours after sunrise and two hours before sunset* look better, especially with digital cameras that sometimes have a hard time taming harsh midday sun.

Keep your compositions simple Clutter is the bane of powerful landscape imagery. Look for simple, powerful compositions, and skip the rest.

This image employs a few helpful landscape techniques: a low horizon line provided a "big sky," late afternoon shooting took advantage of "magic light," and capturing a high resolution allowed for cropping to fine-tune the composition.

Don't put the horizon line in the middle of the frame Landscapes become more powerful when the horizon line is in the lower or upper third of the composition. You can create a very dynamic composition by putting the horizon very low in the frame and letting the sky dominate the scene.

Look for converging lines to give the eye a path to follow A diagonal line adds energy to the composition and can help to lead the eye to a primary point of interest.

Alternate between dark and light tones This is a technique that Ansel Adams used quite effectively, finding a dark tone for the bottom of the frame, then a light tone, then another dark area (usually a shadow of some sort), then bright again, and possibly dark again at the top of the frame. Alternating tones add plenty of visual interest.

Use a tripod when possible By keeping your camera rock-steady, you will squeeze every bit of sharpness out of the lens, rendering even the tiniest elements with clarity. Plus, photographers who use tripods tend to study their scenes more and have more refined compositions.

Be patient Sometimes you have to wait for nature to paint you the perfect picture. Allow enough time to stay put for a while and watch the light change.

Use a polarizing filter If your camera accepts accessories such as auxiliary lenses and filters, consider adding a polarizing filter to your bag of tricks. Polarizers remove unwanted reflections, deepen color saturation, and bring an overall clarity to the scene. The effect is strongest when the sunlight is coming into the scene from over your shoulder.

Protect against lens flare by shielding the front glass element of your camera from the sun Lens flare is that demon that degrades the color saturation of your images. Lens hoods were once standard issue for 35mm cameras, but no one seems to use them for digitals. To improve the quality of your shots, make sure the sun is not reflecting off the front of your lens. If it is, shield it with your hand, or better yet, with this book, which is a perfect size for the job.

Shoot at the highest resolution and sharpness your camera allows Landscapes look best when printed big, but to do so you need all the resolution your camera can muster.

Get out and walk If you see a good shot from the seat of your car, chances are that it's even better a few hundred yards away from the road.

Don't increase your ISO sensitivity setting to cope with low light Bumping up your speed will degrade the quality of your image. Use a tripod and your self-timer instead when the light fades.

By keeping these tips in mind, and by reviewing *Composition (What to Think About While Looking Through the Viewfinder)* in Chapter 2, you can begin to master the craft of landscape photography with your digital point-and-shoot camera, and take some great shots while doing so.

Capture Engaging Travel Locations

When you're on the road, approach your travel photography the same way a director thinks about filming a movie scene. The first frame, often called the *establishing shot*, is the point of interest itself, such as an old church. The second image is a nicely-framed portrait, with an *element of the structure* included in the picture. If the subject warrants it, you might even want to move in very close for a third shot, or several follow-ups.

A beautiful landscape shot helps establish the mood of your travel location.
Photo taken in Sebastopol, Calif.

On the other hand, if all of your travel compositions are tightly framed, your viewers won't know the difference between Denmark and Detroit. By using the multiple-shot approach, you establish both the setting and the detail of each location. This method is particularly effective when building slide shows.

TIP ▼

Make sure you pack a spare memory card and extra batteries when you hit the road with your digital camera. These compact picture-takers are perfect travel companions, but you don't want to run out of storage space or juice halfway through your trip.

Why multiple shots? For the same reason moviemakers use this technique. If you try to tell the whole story with just establishing shots, your viewers may soon lose interest in the presentation, and you may miss interesting details. That's the problem with so many vacation shots—they're taken at too great a distance.

But don't stop there! Be sure to photograph details of the area too. This will make your presentations more compelling. Shot taken in Sebastopol, Calif.

Don't forget to take pictures of signs and placards. It's a lot easier than taking notes about locations, and the information comes in very handy when recounting your travel experiences. Signs can also be a source of humor for your presentation—you never know what some people are going to post in public!

Signs can be beautiful as well as informative.

Take Pictures at Weddings

Weddings are portrait heaven. Your subjects look sharp, are happy, and are in pretty settings. All you have to do is have your camera ready for the opportunities as they present themselves. Here are a few tips for great wedding shots:

Rule one is to not interfere with the hired photographer's shots If you want to follow in their wake for special posed portraits, simply ask permission to shoot a couple of frames after they finish. Most pros will accommodate these polite requests.

Now turn on your flash and leave it on, indoors or out See *Flash Modes* in Chapter 2 for an overview of your options and how to use them.

When you're taking group shots, remember to position your subjects as close together as possible Generally speaking, people stand too far apart. Tightening up the spacing will make for better shots.

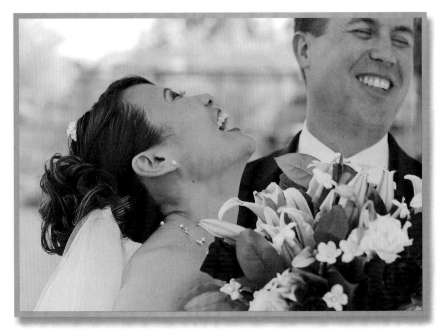

Even if you're not the hired photographer, there are plenty of opportunities for capturing pleasing images at a wedding. Just follow the action and have your camera ready. Photo by Paige Green.

TIP ▼

If your camera accepts an external flash, consider getting a *flash bracket* to elevate the light source above the camera. A dedicated cord connects the flash to the camera's hotshoe. Elevating the flash eliminates red eye and moves distracting shadows out of the frame.

Make sure everyone in the group has a clear view of the camera If they can't see the camera, the camera can't see them. The choice for large groups is simple: either vary the height of those in the group by arranging them on steps or risers, or raise the camera angle above their heads and shoot downward. If you have to, stand on a stable chair to get a better angle for group shots.

Keep an eye out for candids too Look for those special moments that make these gatherings so memorable—last-minute preparations, a kiss on the cheek, a sleepy child in a guest's arms, the perfect toast, a romantic dance sequence, or guests signing the guestbook—these are all potentially great photographs, just waiting for you to shoot them.

Finally, don't forget to include props in the shots when they're available A hint of wedding cake in the background or a beautiful flower arrangement could be the frosting that adds the perfect finish to your portrait.

TIP ▼

When you are the photographer in charge, here's a tip on how to work with guests who want their own shots of the bridal court, happy couple, and family group portraits. Let everyone know that you are going to get the shot first, and to please refrain from shooting. Once you've finished, hold the subjects in place while you turn over the floor to the *paparazzi*. All the guests then click away in a picture-taking frenzy. Once they've finished, you retake control of the floor and set up the next shot. It's fun, and everyone gets to participate.

Prevent Red Eye

Your subjects are vulnerable to red eye in dimly-lit rooms when their pupils are open wide. The effect is actually caused by the light from the flash bouncing off the back of the eye and being reflected back into the picture-taking lens. Point-and-shoot cameras are notorious for causing red eye, because the flash is so close to the lens; this makes for a perfect alignment to catch this reflection.

Even though many cameras provide a setting to reduce red eye (see *Flash Modes* in Chapter 2), they don't always work well and actually can be irritating to both subject and photographer. Instead, try these suggestions when shooting in low light:

- Have the model look directly at a light source, such as a lamp, before taking the shot. This will constrict the pupils and reduce red eye.

- Turn up the room lights if possible.

- Shoot off to the side of the subject, or have the model look a little to the left or the right of the camera, not directly at the lens.

- Use an external flash mounted on a bracket. This is how wedding photographers cope with this problem. It works by changing the angle of reflection from the retina.

- Try an existing-light portrait, if the conditions are suitable.

If all else fails, you can touch up the photograph in an image editor after uploading it to your computer. It's not a perfect solution, but thanks to friendlier computer technology it's easier than it used to be.

Capture Action Shots

The keys to capturing effective action shots are to shoot at your camera's highest resolution, use a fast shutter speed, and take measures to reduce shutter lag.

Two of the most important techniques for stopping action and capturing the decisive moment are to use a fast shutter speed (1/250 of a second for this shot) and to enable Burst mode, which allows you to fire off a rapid series of frames. You can then pick the best image from the sequence. Picture taken at Universal Studios, Calif.

Following these suggestions will improve the quality of your action shots:

First, set your camera at its highest resolution. You will probably want to crop your image later to bring the action closer. Having extra pixels effectively extends the reach of your lens, which is very helpful for this type of photography.

The key to "stopping action" is to use a fast shutter-speed setting. Typically, you should use a speed of at least 1/250, 1/500, or 1/1,000 of a second. The programmed autoexposure mode on most digital cameras is calibrated to give you the fastest shutter speed possible, so you don't need to monkey too much with your camera settings when going after action shots.

However, what you really need is lots of light. The brightest hours of the day are best (usually from 9:00 a.m. to 4:00 p.m.). Shooting outdoors during these times should produce shutter speeds of 1/250 of a second or faster. If your camera has a shutter priority mode, you can set the speed yourself and let the camera handle the corresponding aperture setting.

Unfortunately, a fast shutter speed doesn't help you overcome the lag time between the moment you press the picture-taking button and the moment the shutter actually fires. Shutter lag is the nemesis of point-and-shoot action photographers, and overall, it's the number one complaint about consumer digicams. Even inexpensive digital cameras should offer two features to help you combat shutter lag:

- The first is *Burst mode*, which allows you to take a rapid sequence of shots. If you start the sequence right as the action is initiated, your odds of capturing the decisive moment are much higher. (See *Burst/Continuous Shooting Mode* in Chapter 2.)

- The other trick is to preset the focus, thereby disabling the autofocus system and shortening the lag time between pressing the picture-taking button and actually recording the picture. The best way to do this is to use a function called *infinity lock*. With this function, the camera locks in the focus at infinity, which provides you with a focus range measuring about 10 feet to the horizon. Once infinity lock is engaged, you can fire at will, without relying on your camera's autofocus system. (Sometimes you have to switch to landscape mode to activate infinity lock. This doesn't seem intuitive, but often it works.) For more information on this function, see *Infinity Lock* in Chapter 2.

REMINDER ▼

If there's not enough light to use a fast shutter speed to stop the action, increase your ISO speed setting to 400 for compact cameras and up to ISO 1600 for DSLRs. You'll gain a little image noise in the bargain, but it might be worth the trade-off to get a better shot.

Another helpful technique for action shooting is called *panning*, in which you follow the moving subject during exposure. Using this technique may feel odd at first, because you're taught to always hold the camera as still as possible when taking the picture. But panning can provide stunning results. If you follow the subject accurately, it will be in focus while the background displays motion blur. This effect gives the photograph great energy and a sense of movement.

The classic panning exercise is to have a bicyclist ride by while you keep the camera fixed on the rider during exposure. Use focus lock and Burst mode to give yourself the best odds for timing the shot correctly. You may not be able to fully appreciate the effect on your small LCD monitor, but when you upload the images to your computer, you'll see a wonderfully blurred background providing the sensation of motion.

If your camera has an image stabilizer, check its settings for a panning mode. By using this mode, the camera will try to minimize up and down, but will not interfere with your horizontal panning motion. Once you've finished the shoot, be sure to return your camera to its regular settings.

Shoot in Museums

Museums, aquariums, and natural-habitat parks provide opportunities for unusual shots. They also present some difficult challenges for the digital photographer, but nothing that can't be overcome with a little ingenuity.

Before you get too excited at the prospect of shooting beautiful works of art in a museum, be sure to ask whether it's OK. Often, you'll discover that photography is allowed in some areas, but not in others. To avoid embarrassing confrontations, ask when you first enter the facility.

TIP ▼

Sometimes it pays to look like an amateur. Museums and other public places tend to be more concerned about pros. If you pack an amateur camera and act like a tourist, you will probably draw less attention from security officials.

Even when you're granted permission, you'll probably be told that you can't use a flash or set up a tripod. So, here are a few tips to help you work around those constraints:

Check your white balance Chances are your images are displaying a noticeable reddish hue on your LCD monitor. Try using the Tungsten setting to improve the color balance. Some cameras allow you to set a custom color balance. You might want to give that a try if the presets don't provide the results you want. For more information on white balance in general, see *White Balance* in Chapter 2. To set a custom white balance, see the section *Get It Right with Custom White Balance*, later in this chapter.

Find a way to combat the low ambient light that is often found inside museums Chances are that the camera shake symbol is flashing on your LCD monitor, telling you your pictures are going to be soft due to a slow shutter speed.

If your camera has a neck strap, you can use it to help steady the shots Pull the camera out from your body until the strap is taut. Use this resistance to steady your hands as you make the exposure. You can also lean against a wall or pillar, if one is available, to help you combat camera shake.

As a last resort, you can increase your camera's light sensitivity by adjusting the ISO speed setting Changing the setting to 400 or more might get rid of the camera shake warning, but your picture quality won't be as good. For more information, see *ISO Sensitivity* in Chapter 2.

Regardless of the type of museum you're visiting, you're probably going to encounter exhibits behind glass. The trick to eliminating unwanted reflections is to put the outer edge of the camera's lens barrel right up against the glass, hold the camera steady, and then shoot (make sure the flash is turned off!). By putting the lens barrel close to the glass, you eliminate those nasty room reflections that often ruin otherwise beautiful shots.

Many great shots are often on the other side of glass. You can overcome that barrier by turning off your flash and putting the lens barrel up against the surface. Take care not to smudge the glass or disturb the occupant on the other side.

When you upload the pictures from your visit to the museum, aquarium, or other exhibit, you'll probably notice that many of the images suffer from softness and other flaws that you didn't detect on the LCD monitor. Don't despair, though—even if only a fraction of your images survive, they'll be treasured for years to come and are well worth the effort of capturing.

TIP ▼

The same technique you use for shooting museums also works for clouds through an airplane window or cityscapes from your hotel room. Put the camera lens right up against the surface so that you don't get any unwanted reflections. Then, turn off the flash.

Shoot Architecture Like a Pro

Adding pictures of buildings and their interesting elements to your travel portfolio brings another dimension to your presentations. Most of us don't carry bulky "swivel and tilt" 4×5 professional cameras, but if you follow these suggestions, you'll be surprised by the results you can achieve with your compact or DSLR.

You may have noticed a phenomenon called *converging lines* when taking pictures of large buildings. Instead of the structure standing straight and tall, the lines of the building slant inward so that it looks like the building is falling backward. This effect becomes more pronounced the more you angle your camera upward to compose the shot. To some degree, this is a natural effect that viewers accept. Even in real life, looking upward at a tall building creates converging lines. We don't think about it much, but when the effect is extreme, it can detract from your photos.

If you want to lessen this effect, there are a few things you can do. If you can get some distance from the building you'll find that you don't have to hold your camera at such a severe angle, which will minimize the convergence of lines. You can zoom in with your lens, if necessary, to tighten the composition. You can also elevate your position, such as shooting from an upper floor of a building across the way. This allows you to hold your camera relatively parallel to the structure, which again lessens the effect. DSLR shooters who are serious about architectural photography might consider renting a tilt shift lens that is specially designed for this type of shooting. The Nikon 28mm f/3.5 PC Nikkor AI-S and the Canon TS-E 24mm f/3.5L are two examples of lenses that allow for shift movements, enabling you to minimize the effect of converging lines.

But don't limit yourself to shooting only the big picture: architectural elements are often just as interesting (if not more so) than the complete structure. Look for interesting designs around windows, over doors, and along the roofline. Zoom in on specific areas

that interest you or elements that you might have missed during casual observation. To enhance textures and depth, look for side lighting which often provides more interesting images than flat front lighting does. And don't forget to grab a couple of snaps of signs and placards to help you tell the story once you return home.

Morning light is particularly good for architecture. The angled light gives good definition to structural elements, plus adds a warm glow to the scene. Photo taken in San Francisco.

TIP ▼

Side lighting is good for buildings because it enhances texture, but it's not so good for people, for the same reason.

Gaining Speed

Going by the old saying, "You have to learn to walk before you can run," I bet by now you're jogging at a nice clip. In this section, I'll teach you some of my favorite shooting techniques, share some clever tips, and give you a few new ways to put your cameraphone to use.

Capture Existing-Light Portraits

By now, you've probably realized one of the great ironies in good portrait photography: the flash is your friend when working outdoors. So, guess what the great secret is for indoor portraiture? That's right; sometimes it's better to turn off the flash. Some of the most artistic portraits use nothing more than an open window and a simple reflector.

The problem with using your on-camera flash indoors is that the light is harsh and creates an image filled with contrast. *Harsh* and *high contrast* are two terms that models don't like to hear when it comes to picture descriptions.

This existing-light portrait was captured indoors with an 85mm lens at f/1.8. The custom white balance was set with the aid of an ExpoDisc to get accurate skin tones.

Fill flash works outdoors because everything is bright. The flash "fills" right in. But ambient light is much dimmer indoors, and the burst of light from the flash is much like a car approaching on a dark street.

Of course, sometimes you'll have no choice but to use your camera's flash indoors. It's very convenient, and you do get a recognizable picture. But when you have the luxury of setting up an artistic portrait in a window-lit room, try existing light only.

First, position the model near a window and study the scene. You can't depend solely on your visual perception, because your eyes and brain will read the lighting a little differently than the camera will, especially in the shadow areas. You will see detail in the dark areas that the camera can't record.

This is why you'll probably want to use a reflector to bounce some light into the shadow areas. Many photographers swear by collapsible light discs, but a large piece of white cardboard or foam core will work just as well. Place your reflector opposite the window and use it to bounce the light onto the dark side of the model's face. This will help to fill in the shadow area so that you can see some detail.

Now put your camera on a tripod and slowly squeeze the shutter button. Review the image on the LCD monitor. If the shadow area is too dark, you may want to add another reflector. If the overall image is too dark, turn on exposure compensation, set it to +1, and try another picture. If the color balance of the image is too cool (bluish), you may want to set the white balance control to Cloudy and see whether that improves the rendering.

Remind your model to sit very still during exposure, because you may be using a shutter speed that's as slow as 1/15 of a second, or even slower. You can increase the camera's light sensitivity by adjusting the ISO speed to 200, but don't go beyond that setting. The image quality will degrade too much for this type of shot.

Once you've played with these variables, go back to the artistic side of your brain and work on the composition. Try to get all the elements in the picture working together, and let nature's sweet light take it from there. When it all comes together, existing-light portraits are magical.

Take Pictures from the Stands at Sporting Events

Speaking of not using the flash, how many times have you seen hundreds of cameras firing off from the stands during a sporting event in a large stadium? Alas, what a waste of battery power and space on memory cards (though entertaining to watch).

The flash range of most point-and-shoot cameras is about 10 feet. That means if you're shooting from the stands, you're illuminating only a couple of rows of seats in front of you. Instead, turn off your flash and use existing-light techniques. If you can adjust your camera's ISO setting (see *ISO Sensitivity* in Chapter 2), bump it up to 400. This will increase your camera's light sensitivity.

I pushed the ISO up to 1600 to get the 1/180 shutter speed I needed for this action shot. By catching the player at the peak of his accession, I was able to come away with a fairly sharp image. Captured at Oracle Arena, Oakland, Calif. Player is Monte Ellis.

When you take the shot, hold the camera very steady, because the shutter speed will be slow and you'll want to minimize camera shake, which degrades image quality. If you have image stabilization, turn it on. Better yet, use a monopod if the situation allows.

Even if you hold the camera steady, the action on the playing field will blur, so try to make your exposures right after, or before, the action.

Obviously, you're not going to get *Sports Illustrated* shots from the cheap seats. But for memorable occasions, such as your hometown team winning the World Series, it's great to have a few well-exposed images from the event to keep in your scrapbook.

Produce Do-It-Yourself Product Photography

There are two ways to shoot items for sale on eBay: the hard way and the easy way. The hard way involves multiple studio lights, softboxes, umbrellas, and seamless backdrop paper. Professionals use this equipment to produce outstanding images for commercial advertising and high-end editorial work.

But if you just want a nice picture of your old 35mm camera to sell online, or you want to photograph a small item to put on your website, you probably don't want to set up an entire studio. So, here's the easy way:

1. Find a window next to which you can set up a table. North-facing windows are great, but not necessary for this type of shooting. Cover the surface with white paper and, if you can, create a white backdrop too. This will be your work area.

2. Put your camera on a tripod (or another stable surface) and adjust it so that it's facing the item you want to photograph on the table. Move both the subject and the camera to achieve the best lighting possible via the window. Once everything is in place, make a tabletop reflector out of white cardboard, or cardboard (or another rigid material) covered with aluminum foil. Position the reflector opposite the light source (window) so that it bounces light onto the shadowy side of the item.

3. Set the white balance to Cloudy (see *White Balance* in Chapter 2 for more information) and put your camera on self-timer (see *Self-Timer* in Chapter 2). Now trip the timer and stand back. After 10 seconds or so, the camera will take the shot for you to review. Continue refining your setup until you get the shot you want.

This simple setup can produce studio-like results for a fraction the cost or effort. Give it a try.

Here's an even simpler setup for small items: a white book flanked by CD sleeves on each side and some textured watercolor paper for the background. Custom white balance was used to help balance the very cool light from the window.

The result: a clean, sharp, well-exposed image.

Shoot Infrared Images

Infrared photography has been around for a long time, but capturing stunning pictures on film required true perseverance. Digital imaging has changed all of that. Shooting infrared photos has never been easier or more fun.

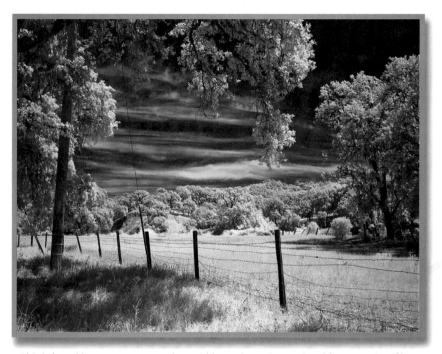

This infrared image was captured at midday, using a Canon G1 with a Hoya R72 filter attached. Because the filter is so dense, the shutter speed was a slow 1/8 of a second.

When you shoot infrared, you're actually dealing with a spectrum of light that's outside your normal range of perception. But with the assistance of a special filter, such as an IR 87 or Hoya R72, many digital cameras can produce the telltale dramatic effects, including a darkened sky, vivid clouds, and foliage emitting an eerie glow.

But not all digital cameras see the infrared spectrum equally. Ironically, as manufacturers made improvements in color fidelity, they often compromised the camera's infrared capability. For example, the ancient Canon G1 records fantastic infrared, but the newer models don't work quite as well.

WARNING ▼

Make sure your new technology (such as a state-of-the-art digicam) does all the cool things its predecessor does before ditching the old camera. Sometimes it's worth holding on to an old camera just for one function, such as capturing great infrared.

If you want to test your digicams to see which one works the best for this type of shooting, line them up on a table in a darkened room. Enable picture-taking mode and make sure the LCD monitor is on. Then point your television remote control at each lens and press a control button, such as the channel changer. The camera that shows the brightest light emitting from the remote control will be your best infrared capture device.

Attach an infrared filter such as the Hoya R72 to your camera, grab your tripod, and look for a brightly-lit scene that has sky, clouds, and trees. Set your aperture at f/5.8 or f/8 to help compensate for the different way infrared "sees" the worldhe focusing plane in this type of photography is slightly different, and the added depth of field produced by a smaller aperture will help to keep things sharp. Be sure to turn on the self-timer so that you don't jar the camera during exposure, and record a frame. The world you see in your LCD monitor will look much different from what you observe with your eyes.

TIP ▼

If you shoot your infrared images in color, you can later convert them to B&W on your computer. You can also create some interesting effects on the computer by converting only selected areas to B&W and leaving others in color. You'll need a good image editor (Photoshop Elements is an affordable option) to achieve this effect.

Take Flash Pictures of People Who Blink at Flash

Every now and then you'll run into someone whose eyes are very sensitive to flash and who has a knack for blinking right as the flash fires. The result is a series of unflattering facial expressions and lots of frustration.

One of the best tricks to help calm the nerves of model and photographer alike is to use the red eye reduction mode. (See *Flash Modes* in Chapter 2 and *Prevent Red Eye* earlier in this chapter for more information.) The preflash that is designed to reduce red eye will actually cause the model to blink early, so her eyes will be open when the exposure takes place. It works almost every time.

Use Sunglasses As a Polarizing Filter

Point-and-shoot cameras are the height of convenience, but not always versatility. A case in point is when you want to mount a polarizing filter to saturate the sky or reduce glare. There's nowhere to put it!

But that doesn't mean your pictures are doomed to the blinding glare of a reflective world. You can, instead, remove those stylish neutral gray polarizing glasses from your head and place them in front of the camera lens. Quality sunglasses make great polarizing filters for compact cameras.

Make sure the lens of your sunglasses completely covers the front glass element of your camera. You'll get best results when the sun is aligned along your shoulders.

You don't believe it works? Take two shots, one with the sunglasses and the other without. You be the judge.

Shoot Fireworks

If you check the Scene Modes on your digital camera, chances are you'll have a setting for capturing fireworks. These presets work great, but you might want to know what's happening under the hood in case you have to work with a camera that requires manual configuration. Here's the setup procedure:

1. First, turn off your flash. Yes, you're going to be shooting in a dark environment, and if your camera is set to auto flash, it's going to fire. This is the last thing you want, so disable it by selecting Flash Off from your flash menu.

2. Next, break out the tripod. You're going to be making long exposures (one second or more). Use a cable or remote release if you have one. If not, just gently press the shutter button with your finger. Keep in mind that you'll need the tripod even if you're using the Fireworks setting in the Scene Modes.

3. Resist the urge to increase your ISO setting. Keep it at 100 to help reduce image noise. Remember, your camera is on a tripod, so you don't need to worry about camera shake.

4. You may also want to switch to manual exposure. Autoexposure will overexpose your dark skies, turning them to mushy gray. Start with a manual setting of two seconds at f/5.6 or f/8, and see what you get. Adjust accordingly from there. If you don't have a manual mode on your compact camera, set the exposure compensation to -2. This workaround tells your camera to underexpose the dark sky by two f-stops, helping to keep your blacks black.

5. Finally, set your lens to wide angle so that you can capture as much of the sky as possible. If you know the display is going to peak in a certain area, you can zoom in a bit. Remember, since you're shooting at the highest resolution possible, you can always crop your image later.

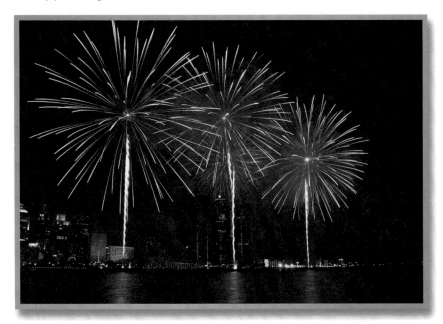

With a little practice, you can take excellent fireworks shots. This shot of the Freedom Festival fireworks over the Detroit skyline was captured by Brian C. Davenport. The zoom on his Digital Rebel XT was set to 18mm, ISO 100, f/8, and a 3–5-second exposure.

Take lots of pictures. Over the course of the evening, you may capture only one or two acceptable shots—but they will be spectacular.

Get It Right with Custom White Balance

Your camera comes loaded with a handful of white balance presets, such as Tungsten and Fluorescent. These presets can produce better color under artificial lighting than the auto white balance setting.

TIP ▼

You can use white balance presets creatively too. For example, if you use the Tungsten preset (which makes things bluer) for an existing-light portrait in daylight, you can create a somber, moody feel for the shot. Some photographers like to use the Daylight preset for sunsets to accentuate the warm colors. Don't be afraid to experiment!

Presets are exactly that: predetermined settings based on the manufacturer's best guess. Thanks to the sophistication of your camera's built-in electronics, you can read the actual lighting of a scene and create a custom white balance setting tailored to those conditions.

The actual buttons you push vary from camera to camera, but the basic procedure goes like this:

1. Find Custom White Balance in your menu settings.

2. Hold a clean sheet of white paper so that the light source is reflecting off of it.

3. Point the camera at the white paper and push the appropriate button, causing the camera to measure the color temperature of the light bouncing off of it.

That's it! You've now created a custom white balance setting that should produce a realistic rendition of the scene you're shooting.

As a variation on this technique, you can use a basket-style coffee filter instead of a sheet of paper. Hold the filter over the lens, point the camera at the light source, and then take a reading. You may want to turn off autofocus, or switch to infinity mode, so your camera doesn't try to focus on the filter. Keep in mind that all you need is the light temperature reading, so focusing isn't required.

TIP ▼

You can also buy calibrated accessories, such as the ExpoDisc (*http://www.expodisc.com*), which is designed to produce even more accurate results with the Custom White Balance setting.

Once you're finished shooting the scene, don't forget to return your camera to Auto White Balance mode. You don't want to shoot that gorgeous landscape tomorrow with the white balance calibrated for fluorescent lights!

Protect Your Camera from Condensation and Dust

One of your most valuable photo accessories isn't available at your local camera store—a Ziploc bag. This highly sophisticated, multipurpose device can protect your camera from rain, condensation, and dust.

First, you need Ziploc bags that are large enough for your camera to fit inside with the zipper securely sealed. I recommend the one-quart size for compacts, and as big as you can get for your DSLR body.

Notice that I said "bags." You'll want at least two in your camera kit, because if one gets soaked or dirty, you want to have a replacement on hand.

After shooting in cold weather, put your camera in the bag and seal it before going back indoors. Leave it in there until it completely warms up. That way, the condensation will form on the bag and not on the camera.

If rain strikes, but you're not ready to stop shooting yet, cut a hole in the bottom of the bag that is large enough to poke the lens through. You can stick your hands through the open end of the bag to hold the camera and operate the controls.

Dusty conditions are nerve-racking for photographers. Keep your camera in the Ziploc while not in use. If conditions are extremely bad, use the rain protection technique to shield your camera from blowing particles.

Extremely humid conditions are hard on cameras and optics. Stock up on silica gel bags and put them in a sealed Ziploc along with your camera. This helps to protect your equipment from long-term exposure to high moisture levels.

Devise a Shower Cap Inclement-Weather Protector

The loyal companion to the Ziploc bag is the hotel shower cap. These free accessories are the perfect rain protectors for all of your compact cameras. Just poke a hole in the middle of the cap for the lens to protrude through, put your hands through the stretchy opening, and let the elastic close tightly around your wrists.

You now have a water-resistant cover that enables you to work all of the camera's controls—perfect for those shots of the kids splashing water in the gutter on a rainy day.

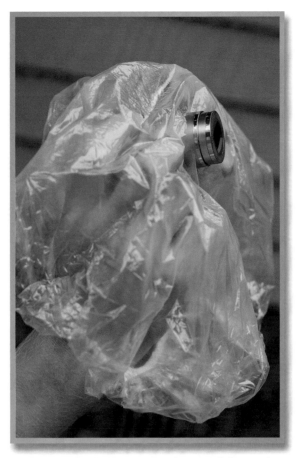

Just cut a hole in the center of a shower cap that's big enough for your lens, and you have an all-weather protector for your compact camera.

Capture Time-Lapse Movies

Do you remember watching a movie of a butterfly emerging from its cocoon? You probably saw it as a kid in school. That's a classic example of time-lapse photography—a series of images captured at regular intervals (usually between one second and one minute each), and then played back as a movie.

Chances are good that you can create your own time-lapse magic with your digital camera. Some high-end compacts, such as the Canon G9, have this function built right into the camera. If you enjoy this type of movie making, having the capability built into the camera is definitely the way to go because you don't have to lug your computer around.

Simply mount your camera to a tripod, compose your shot, and start recording. (You can use a tabletop or any other stable surface if you don't have a tripod with you.)

The more common scenario is to connect your camera to your laptop and use the remote capture application that's (hopefully) included in the software bundled with your camera. Most DSLRs have this capability, as do a good percentage of compacts.

The only difference in the procedure is that you need to attach your USB cable so that the camera can talk to the computer. Then launch the software. Make sure you have enough power for both pieces of hardware. You don't want to run out of juice in the middle of the shoot.

Once you have everything in place, configure a test movie. Capture at the best resolution possible (640×480 or higher) and set the timer for intervals that make sense for your subject. If you're shooting people activity, two seconds or so in between exposures is a good starting point. For landscapes and other nature subjects, you might want to back off to once a minute or so. Review your test movie, and if everything looks OK, record the real thing.

If you don't have any time-lapse software at all, you can go the manual route. Set up your camera and trip the shutter yourself. I recommend that you use the self-timer so that you don't accidentally jar the camera at exposure. Then take all of the images you captured and create the movie using QuickTime Pro. You can read more about how to do this in Chapter 4, in *Convert Still Images into a Movie*.

Preview Your Shots in B&W

Many cameras have a B&W mode that enables you to capture grayscale images. This type of photography presents us with a graphically-rich alternative to the common color version of the world around us.

The problem with B&W mode is that grayscale images are your only option. You may think you want only B&W at the wedding reception ... until the bride asks for color versions two weeks later. I recommend that you capture your pictures in color, and then convert copies of them to B&W. That way, you have all of your options open. (See *Convert Color Pictures to B&W* in Chapter 4.)

But there's still value to B&W mode, even if you choose to capture in color. It can help you preview your compositions in grayscale on the camera's LCD monitor. By doing so, you can better compose your scene for the best B&W output later on while working on your computer. Also, it's quite fun.

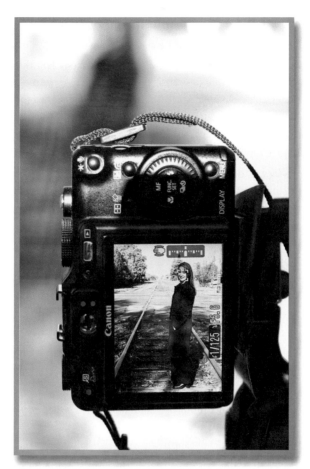

Even if you're ultimately going to capture the shot in color, you can see how it would look in B&W by turning on the monochrome or B&W mode on your camera.

TIP ▼

Photographers who have the raw format available on their cameras can capture in B&W and color at the same time. Set your format option to RAW+JPEG (instead of JPEG only), and your effects option to B&W (or monochrome on some cameras). When you copy the files to your computer, the JPEG will be in B&W, but you still have all of your color options available to you with the raw files. This is a terrific option for wedding photographers whose clients want an option of color or B&W for every shot recorded.

Extend the Dynamic Range of Your Image

Cameras don't see the world as we do. Our eyes (connected to our supercomputer brains) can pick out the shadow detail of a shaded tree trunk and the subtleties in a bright sky at the same time. Your typical digital camera can't. At the root of this discrepancy is something called *dynamic range*, the ratio of the lightest to the darkest point in the scene. On a bright day, our optical system can easily see 50,000 subtle variations in tone. A typical 8-bit photo captured by your camera picks up a mere 256 variations. Considering these limitations, it's a wonder our pictures turn out as well as they do.

To compensate for this difference in dynamic range, photographers sometimes shoot through a *graduated density filter*, a piece of glass which darkens the sky (typically the brightest part of a photo) in hopes of compressing the scene's tonal values so that the camera can record them all in one exposure.

Traditional Approach: Graduated Filters

Graduated density filters work great when you have a simple bright area, such as a sky, with a clean horizontal line. The filter itself is dark at the top, usually a neutral gray, and it then gradually gets lighter toward the bottom. The thinking is that you position the dark area of the filter over the bright sky, bringing its exposure more in line with the landscape. Graduated filters are usually mounted with a holder that allows you to slide them up and down for precise alignment with the tones in your composition.

They work amazingly well, except in more complicated scenarios, such as a brightly lit window in the middle of a dark room, or a landscape with a jagged mountain range.

High Dynamic Range with Photoshop

In the complicated scenarios I just mentioned, the better solution is to take multiple shots—for example, exposing one for the window and another for the interior—and then combine the images in Photoshop. Until recently, however, this technique required quite a bit of patience and skill.

Since Photoshop CS2, Adobe has included a Merge to HDR (High Dynamic Range) command that automates the process of combining pictures with different exposures. The result is one image with an extended dynamic range, closer to what you see with your eyes.

Creating an HDR image begins at the camera. Instead of capturing just one shot of a scene, you'll need to shoot three or more frames, exposing each shot slightly differently.

For best results, use a tripod when shooting to ensure that each frame is perfectly aligned with the next. This will make it easier for Photoshop to merge the images later. Before you begin, set your camera to shoot at the highest resolution and with the least amount of compression possible. (You want to squeeze every bit of information out of your JPEGs.) Then put your camera in Program mode, compose the scene, and lock the tripod.

To capture a simple three-frame series, use the camera's exposure-compensation control to underexpose the first shot by two stops. For the second shot, set exposure compensation to 0, which represents your normal exposure. Finally, take the last picture at +2 exposure compensation to overexpose by two stops. You can play with this formula depending on the tonal range of the scene. For example, you may want to bracket only one stop instead of two, or you might take five photos, bracketing from -2 to +2.

If you don't have your tripod handy, you're not necessarily out of luck. Here's a workaround that I use for those situations. First, turn on your camera's continuous-capture mode so that you can record frames in rapid succession. Then find the Auto Bracketing setting and select an exposure variance, such as -1, 0, +1 or -2, 0, +2. Compose your scene. While keeping the camera very steady, hold down the shutter button until all three frames have fired. Keep in mind that this technique works only with static scenes. If you have people moving around or waves breaking, you probably won't like the results.

Now you have all of the information you need to assemble your HDR image. For instructions on processing, see *Processing HDR Images in Photoshop* in Chapter 4.

Shoot Underwater Portraits

Many compact cameras have optional underwater housings available as accessories. For a couple hundred dollars or less, you can expand your picture opportunities to lakes, oceans, and yes, even swimming pools. Want to get a unique portrait of the kids? Have them don their swimsuits and head to the local watering hole.

Kids are naturally animated in water. They're having a blast. And you can be there with your camera recording all of the action. Underwater shots aren't just for pretty fish.

The key to successful underwater photography is to stay close to the surface where the light is best, and use the camera's Underwater scene mode to help balance the color properly. If you don't have that particular scene mode, change your white balance to the Cloudy preset. This will help to offset the strong blue tint of the water. Also check that your image stabilizer is turned on. It will help you capture sharper shots, even while floating.

*This underwater portrait was captured with a Canon Digital Elph
with its accessory underwater housing.*

Be sure that the "O" ring that runs along the inner perimeter of the housing is lubricated
and seated properly.

REMINDER ▼

You may have bought your underwater housing for that trip to Hawaii, but it can
provide you with many unusual photo opportunities year-round, even in the back-
yard sprinklers.

Create a Pantyhose Diffusion Filter

A flattering portrait is often praised for its soft lighting, good angle, and natural expres-
sion. You'll rarely hear a subject rave about a picture that highlights pores, wrinkles, and
blemishes. Sometimes camera lenses can be too sharp.

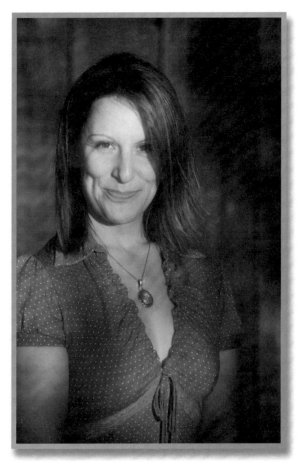

A knee-high stocking was stretched over the lens to soften this portrait.

A popular solution used by portrait pros is a diffusion filter. Simply put, these accessories attach to the front of the camera lens and downplay the appearance of texture on the face. The wrinkles don't go away; you just don't notice them as much.

These filters can cost as much as $200. That's one thing if you shoot portraits for a living, but what if you just want a nice shot of your sweetheart?

Ask her for her pantyhose. Or perhaps, these days, it's easier to just go to the nearest supermarket and grab a pack of sheer knee-high stockings.

That's right. By stretching a piece of light beige fabric over the front of your lens and securing it with a rubber band, you can create a flattering effect similar to that used in professional portraits. (I prefer knee-highs to pantyhose because they take up less room in my camera bag.)

The technique is simple. Use a telephoto lens (in the 85mm–300mm range), set your camera to Portrait mode, stretch the pantyhose across the front element, and shoot away.

Keep Your Tripod Steady with Tennis Balls

Have you ever tried to use a tripod in the sand? You might as well be trying to steady your camera on chopsticks in rice.

But you can bring stability to the situation. Buy a can of tennis balls, cut an "X" slit in each one, and slip them over the feet of your tripod. They will provide a much steadier platform for your three-legged friend.

Use Your Car Windshield Cover As a Reflector

Natural-light portraits on a bright, sunny day sometimes are not the most flattering. When the sun is high in the sky, the light can create harsh shadows that overemphasize the nose or highlight facial blemishes.

If you'd prefer not to use a fill flash to balance the light, a reflector just might do the trick. Big reflectors are used on professional shoots all the time to help control the light. The problem is that these accessories can be expensive. Chances are you have an excellent DIY (do-it-yourself) reflector in your car: the windshield cover you use to protect the dash on hot days.

You'll need a photo assistant for this shot. Have your helper hold the white side of the windshield cover a few feet from your subject so that it reflects light back into the subject's face. You might have to play with the position for a minute or two before getting it just right. Then take a series of photos and review them on your camera's LCD viewfinder. If you need more light, use the silver side of the reflector. Just be careful that you don't blind your subject!

With a little practice, you'll find that you can make great portraits with this simple, affordable photo accessory.

Use Your Cameraphone As a Visual Note-taker

More and more, the smartphone is the camera we always have with us. As photographers, we may pooh-pooh the image quality of our cameraphone pictures. But it comes down to using the right tool for the job. True, you're not going to use your Treo to record landscapes during your visit to the Grand Canyon. But you might want to take a cameraphone picture of the hours the park is open so that you know when you can return the next day.

Do you remember where you parked your car?
Your cameraphone can help you find your vehicle safely.

My point is, think of cameraphones as data recording devices. Signs, menus, people you meet, they're all perfect subjects for you to capture with your iPhone and then refer to later when you need the information.

One of my absolute favorite uses for my cameraphone is to take a picture of the sign in the ginormous parking lot where I leave my car before boarding a plane. A week later, when I'm on the shuttle from the terminal to the parking lot, all I have to do is refer to my phone to see exactly where my car is located. It's wonderful!

When traveling abroad, take cameraphone pictures of your hotel, restroom signs, and taxi cabs. Even if you don't speak the language, you can point to the picture on your phone to get help.

Any sort of visual information that you need to remember is fodder for your phone. Don't take notes, take a picture. And with email becoming easier all the time on smartphones, you can then simply attach the photo and send it to yourself or a friend who needs the information.

Where to Go from Here

Now it's time to shoot. The best thing about digital cameras is that you can take picture after picture without worrying about film processing costs. The best way to learn the art and science of photography is to take lots of pictures.

Keep your eyes open, keep your camera steady, and, most important, enjoy! In the next chapter, we'll move over to the computer and put all of these great images to use.

CHAPTER 4

I've Taken Great Pictures, Now What?

WORKING IN THE DIGITAL DARKROOM

You can divide the process of creating photographs into two basic steps: capture and postproduction. You can carry out these steps by simply capturing a picture with a point-and-shoot camera and then taking the memory card to a nearby store to make prints. Or your workflow can be as involved as controlling every aspect of a shoot with your DSLR and fine-tuning each exposure in Photoshop before making fine-art prints on your large-format printer.

Most of us fall somewhere in between these two scenarios, especially on the computer side of the equation. And that's what this chapter is about: making the computer work as fun and efficiently as the camera did when you took the photos in the first place. You've made great photos. Now what? Well, there's plenty you can do, and it's fun.

Basic Survival Skills

You've just returned from a great two-week vacation, and your memory cards are bursting at the seams with photos and digital movies. Now what do you do?

Before you spam every friend and relative you know with mega-megapixel masters, take a few minutes to learn about sampling down images so that they have smaller file sizes. You'll also want to archive your pictures so that you can find them again months later, when you want to relive the great memories. And what about those video snippets you have on your memory card? With a little editing, you can turn them into short movies.

In other words, this section will discuss basic computer techniques that can help you keep your friends happy and your pictures organized.

Keep in mind that many of these survival techniques are also components of full-service photo management applications. Some of these—such as iPhoto, Aperture, Photoshop Elements, and Lightroom—I cover later in this chapter. But what if you don't have those applications? (Or want them!) Don't worry, you won't be stranded. These basic survival techniques are time-tested and require only the software you most likely already have on your computer.

Send Pictures via Email That Will Be Warmly Received

One of the first things that new digital camera owners love to do is send a batch of images to family members or friends. As you may have already discovered yourself, the warmth of reception is inversely proportional to the size of the images that land in your recipients' inboxes.

All too often, budding photographers send full-size 4-, 6-, or even 12-megapixel pictures as email attachments. Unfortunately, these files can be awkward to view comfortably as email attachments and take up unnecessary space on the recipient's hard drive.

Indeed, you should shoot at your camera's highest resolution, but remember not to send those full-size images to others. All parties concerned will be much happier if you create much smaller email versions of your pictures and send those along. This technique is called *sampling down*.

Some photo management applications, such as iPhoto, enable you to simply choose a picture and then click on the Email button (on the lower right) to resize the image and add it as an attachment.

You have three basic options here. First, you can use the export function of modern photo management applications such as Adobe Lightroom to export a smaller copy of your original photo that you can attach to an email. Or some email applications, such as Apple's Mail.app, allow you to change the size of a photo attachment right there while you're composing the email message. If neither of those options is available to you, you can use the tried-and-true sample-down method with an image editor such as Photoshop.

Here's how it works:

1. Use your image editor (either included with your camera or purchased separately) to resize a copy of the image for easier handling. To do so, use the Save As command. The largest size you should send as an email attachment is 800×600 pixels, and 640×480 pixels will usually do the job.

2. If you're lucky enough to have Photoshop (or Photoshop Elements) as your image editor, use the Image Size function to resize the picture. (Other image editors have similar functions.) When you first open the Image Size dialog box, you'll see the current width and height of the picture. In the settings in the following image, those dimensions are 2816 pixels wide by 2112 pixels tall. This shot was taken at full resolution with a 6-megapixel camera. If you sent this picture as is, the file size would be far greater than 2 MB, even after compression, and a full 17 MB when opened. That's not the kind of attachment you want to send to friends and family.

*In Photoshop, the original dimensions of your picture will appear in
the Image Size dialog box under Pixel Dimensions.*

3. Use this dialog box to reduce the width and height settings to 640×480 pixels (or thereabouts). In the preceding example, these changes shrank the compressed file size to less than 300 KB—just a fraction of the size of the original image!

4. Make sure you have both the Constrain Proportions and Resample Image boxes checked when preparing image copies for email. With the Constrain Proportions box checked, Photoshop will automatically change the height dimension for you when you change the width. Photoshop users can also take advantage of the *Bicubic Sharper* algorithm, which you can select from the drop-down list next to Resample Image. Since sampling down sometimes softens your pictures slightly, many photographers feel the need to sharpen the images after resampling. You won't need to use that two-step process if you select Bicubic Sharper. Photoshop will resample and sharpen for you in one step.

DEFINITION ▼

Resampling is probably one of those words you've heard before but you don't quite understand what it means. In simplest terms, resampling means that the image editor is either adding pixels to the image or subtracting pixels from the image. Usually you'll want to avoid sampling up (adding pixels), because that degrades image quality. But sampling down, or subtracting pixels, is a great way to reduce the file sizes of image copies that you want to send via email or post on the Web. In other words, when you change the width and height dimensions to smaller numbers, such as 320×240, you're sampling down, and both the picture and the file size will be smaller.

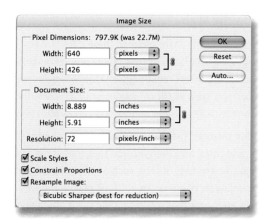

These are appropriate dimensions for emailing pictures entered into the Image Size dialog box in Photoshop. Make sure the Resample Image box is checked. Notice that Bicubic Sharper is selected for resampling. This sharpens and samples down at the same time.

If you have a choice, the best image format to use for email attachments is JPEG (.*jpg*). When you save in this format, your computer will usually ask you which level of compression you want to use. Generally speaking, medium or high gives you the quality you need.

Type of recipient	Suggested attachment dimensions	Don't go bigger than this
Digital Dad and Megapixel Mom	800×600	1200×900
AOL Aunt and Cautious Cousin	640×480	800×600
Newbie Nephew and Dial-Up Daughter	400×300	640×480

Suggested attachment dimensions guide

Remember to keep your original image safe and sound so that you can use it later for printing and large display. To help eliminate confusion when dealing with these different sizes, you might want to save two copies, calling the original something like *vacation_6742_hirez.jpg* and the more compact version *vacation_6742_lorez.jpg* (*hirez* being short for high resolution and *lorez* denoting lower resolution).

If you send friends and family smaller, more manageable pictures, you'll hear more about how beautiful your shots are and less about how much space the darn things took up on their computers.

Share Pictures on the Web

A popular way to electronically share pictures these days is via online photo services that publish web page galleries of your images. Only a few years ago, setting up an online gallery was a cumbersome process requiring some knowledge of web page design. But easy-to-use online services such as Flickr (*http://www.flickr.com*) have streamlined this process so that anyone with an Internet connection can publish photos.

In addition to sharing pictures, these services allow you to write short captions, fine-tune your pictures, add titles, and even include tags that serve as keywords, allowing you to easily find specific types of photos, such as landscapes. Once you've uploaded your pictures to the online service, you can notify all of your friends and family via email. The advantage of this method is that you're sending them only a text link to your photo web page, not actual images that they'll need to download. Also, since the photos are on the service's computer, they won't take up your viewers' valuable hard disk space.

Flickr is an easy-to-use online photo community that makes it easy to share your pictures with anyone who has an Internet connection.

Another advantage of this approach is that viewers can often post comments to accompany the pictures for everyone to read. So, for example, if you've published images from your sister's wedding, everyone in the family can remark on how beautiful she looks and which ones are their favorite shots. This type of photo sharing lets people all over the world participate in the experience, just as though they were all sitting together around the kitchen table with an open photo album.

Some printing services provide free online sharing with the added benefit that visitors can order prints from your galleries and have them shipped directly to their homes. They can even use those images to create calendars, personalized coffee mugs, and greeting cards. For a list of online photo services, visit *www.thedigitalstory.com/dpc*.

Online photo-sharing services have become as easy to use as taking the pictures themselves. If you find yourself spending a lot of time emailing photos to friends and family, take a look at these and other offerings.

Present a Digital Slide Show

Slide shows are an age-old photographic tradition. Digital cameras make it easier than ever to present your images to many people at once.

Most digicams have a "video out" capability that lets you connect your camera directly to a television for playback on a large screen. If your camera has this functionality, it most likely has a slide show mode that allows you to choose images that are stored on the memory card and present them on the television in timed intervals. All you have to do is turn on the stereo for some background music, add a little witty commentary, and you'll have a full-fledged multimedia presentation to share with others.

Another option is to use the software that comes with your camera to assemble slide shows on the computer, and then either show them on the computer monitor or connect the computer to a television for big-screen presentations. Computer slide shows have the advantage of letting you add transitions and special effects to your presentations; plus, you get to select the actual photos you want to show, unlike slide shows on your camera that display everything on the memory card. They can also be saved and played long after the memory card has been erased and reused.

Degree of difficulty	Display device	Suggested software
Easy	Digital camera connected to TV	None, camera does all the work
Moderate	Computer with monitor or laptop	Apple iPhoto, Adobe Photoshop Elements, QuickTime Pro
Getting serious	DVD played on standard TV, HDTV, or computer with big monitor	Apple iDVD, Boinx FotoMagico, Photodex ProShow

How are you going to show your show?

You can also use independent software that didn't come with your camera for your slide show. For instance, Boinx Software's FotoMagico (*http://www.fotomagico.com*) (Mac only) not only enables you to make slide shows from your digital images, but also allows you to incorporate music directly into the presentation. You can even save the show as a QuickTime movie and send it to others.

Dedicated slide show software, such as FotoMagico, provides you with tremendous power to create broadcast-quality productions.

Regardless of which method you use to create your presentations, keep in mind these basic tips that will help make your shows engaging and leave your audience begging for more:

- Include only your best images.
- Tell a story with your pictures as well as with your words.
- Keep your presentations short—3 to 10 minutes is all the time that's usually needed, or wanted, by your audience.
- Add music and anecdotes for more interest.
- Be creative. Add close-ups, distance shots, low angles, and high angles for variety.
- Never apologize for your pictures. If you don't think a picture is good enough to be in your show, don't include it.

Slide shows have never been easier to create, and people do like them when they're done well.

Once You're in the Groove

One of the great things about digital photography is that you have the raw material to work on all sorts of different projects. In this section, we'll move a little beyond the basics for fun, and to make sure you have your imaging house in order.

Convert Still Images into a Movie

You don't need elaborate video software to create short movies from your photos to send to others or post on your website. With QuickTime Pro (Mac and Windows, $30 from *http://www.quicktime.com*) you can build a basic slide show and even add voiceovers or background music.

REMINDER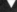

Many consumer photo management applications—such as Photoshop Elements and iPhoto—have more sophisticated slide show authoring tools than our basic survival guide featured here. So, before investing in any new tool, check the software you already have. With that being said, QuickTime Pro has many other handy features that go well beyond this project. It is often referred to as the Swiss Army knife of digital media.

Here are the steps for creating a movie in QuickTime Pro:

1. Select the images you want to use and put them in a separate folder.

2. Open QuickTime Pro.

3. Choose File→Open Image Sequence.

4. Navigate to the folder that contains your photos and click on the first image to highlight it. Click the Open button.

5. Choose "4 seconds per frame" from the Image Sequence Settings dialog box. Click OK. QuickTime will build your movie and present it at full size on your screen. (Don't worry; your final product won't look like this.)

6. Go to File→Export and give your movie a name in the Save As field of the dialog box.

7. Go down to the Export field and choose Movie to QuickTime Movie from the pop-up menu.

8. Click the Options button and make sure the Video box is checked.

9. Click the Settings button and make the following selections:

 Compression Type: Photo-JPEG

 Quality: High

 Click OK.

10. Click the Size button and choose the finished size you want for your movie from the Dimensions pop-up menu. If you don't know, start with 640×480 and see how that works. Also check the "Preserve aspect ratio" box and choose Letterbox from the pop-up menu. Click OK.

11. Check the Prepare for Internet Streaming box and make sure Fast Start is showing in the pop-up menu. Click OK.

12. Click Save and QuickTime will export your movie according to the settings you established as well as place your finished work at the destination you chose.

You now have a basic slide show that can be played on a Mac or Windows computer. (You can also use this method to create your own time-lapse sequence with a series of photos.) The file size should be small enough that you can include it as an email attachment or post it on a web page for viewing online.

Use a file-naming convention of your choice to put your pictures in the correct order.

If you want to change the order of your images before you create your slide show (the default is chronological), rename the photos in the order you want, such as *0001.jpg*, *0002.jpg*, *0003.jpg*, and so on. QuickTime will organize your slide show according to the order you indicate.

If your computer has a microphone (many have them built in), you can also include a voiceover in your movie. The steps are easy, again using QuickTime Pro:

1. Open the slide show movie you've created and make sure you're at the beginning of the movie.

2. Go to File→New Audio Recording. A recording interface will appear.

3. Press the Play button on your movie to start the slide show. This will be your visual cue for your accompanying monolog.

4. Press the red Record button on the Audio Recording interface. Start talking about the slides you see on the movie screen. When the slide show has completed, click the "Stop recording" button. QuickTime will place an *Audio.mov* file on your desktop.

5. Open the audio file by double-clicking it. Go to Edit→Select All, then go to Edit→Copy.

6. Return to your slide show by clicking on its viewing window. Make sure your player is set to the beginning of the slide show (or the location you want the audio to begin) and then choose Edit→Add to Movie. Your audio track is now included as part of your slide show. Click on the Play button to review.

7. Choose the Export setting for your movie again as you did previously, but this time make sure the Sound box is checked. Click on the Settings button for Sound and select QualComm PureVoice in the Format field and Mono in the Channels field.

Once you copy your music to the clipboard, use the Add to Movie command to incorporate it into your slide show. Remember, wherever your marker is located on the playback bar, that's where the music will be inserted.

You now have a movie with both pictures and audio. Keep in mind that you can also incorporate unprotected music into your slide show using the same Add to Movie command and choosing the music file. There are a wealth of additional settings you can use to balance the audio tracks under Window→Show Movie Properties. Click on a sound track that is listed, and then click on the Audio Settings button to reveal Volume, Balance, Bass, and Treble adjustments. You can make separate settings for each sound-track you add. Do this before final export of the movie, and the settings will be carried over to the final production.

Sometimes QuickTime Pro is used to tweak movies created with other software. Open your movie in QuickTime, and then choose the Movie Properties option to make your adjustments.

QuickTime Pro also has some nice playback choices. For example, try View→Present Movie and choose Current Size from the Present At pop-up menu. Then click the Play button. You'll experience a movie theater presentation right there on your computer.

Work with Raw Files

One of the great debates among advanced digital photographers is whether to use the JPEG or raw (or both!) format for recording images. Each format is capable of producing high-quality pictures, but when you shoot in JPEG mode, the camera processes the image for you so that it's complete when you upload it to your computer.

Images captured in raw format, on the other hand, are not complete when you transfer them to your workstation. This process is more like taking a negative into a darkroom, where you can adjust the white balance and exposure until you get the perfect image. It's true that you can make those same adjustments in postproduction with JPEGs, but it's different because you're readjusting information that's already been set. With raw, you are actually mapping the original bits of information losslessly.

One of the battle cries of this book is "Good data in; good data out." The better you capture your shot, the easier it will be to produce high-quality output. Shooting in raw mode means you can delay some difficult decisions until you're in the comfort of your own home, working at your computer.

A good example is determining the correct white balance, which is often difficult at the moment of exposure (especially under fluorescent or mixed lighting). When you shoot in JPEG mode, you have to make an immediate decision, and if you're wrong, you have to figure out how to correct it later.

In raw mode, it doesn't make any difference which white balance setting you select when you shoot the picture. The camera just records the raw data and lets you fine-tune the color later, on your computer. You can apply different color temperatures to the image, compare the results, and then have the computer apply one that you like without any compromise to image quality. It's just like choosing a white balance setting at the time of exposure (only better, because you're looking at a 17-inch monitor, not a 2-inch LCD screen!). With this being said, I still recommend setting the white balance as accurately as possible at the moment of capture. Even though you can adjust the color balance on each and every image in postproduction, why spend the time if you don't need to? Get it right at capture and forget about it.

If your camera has the ability to shoot in raw format, it will include software to work with these images. Photoshop users can also work with raw files right in Photoshop using Adobe Camera Raw. Visit the Adobe site (*http://www.adobe.com*) for more information.

Adobe Camera Raw (which comes with Photoshop) is an excellent image editor for raw files. It can accommodate just about any camera that shoots in raw format.

No matter which software you use, this method is as close as you can come to a true digital darkroom, and it provides you with maximum flexibility for processing your images. Shooting raw images may require more work and processing time later, depending on the software you use. But for situations in which you want absolute control over quality and final output, raw is an excellent option.

Which is best for you? A common-sense approach would be to capture images at the highest JPEG setting for times when you want greater burst rates (action photography) or when you need to use your images right off the memory card (direct printing without a computer). On the other hand, if your camera supports raw files you may want to take advantage of this format for difficult lighting situations, or when you want to squeeze every drop of quality out of your picture-taking process.

And if you still can't decide, many DSLRs allow you to shoot RAW+JPEG. In this mode, you get the original raw file plus a JPEG version. Granted, this approach consumes memory cards faster than Doritos at a Super Bowl party, because you're recording two complete files for every picture captured. The upside is that you have JPEGs available for immediate use, and those super-high-quality raw files for refinement later.

Other uses for RAW+JPEG include direct photo printers (as discussed in *Chapter 5*) that allow you to insert your memory card directly into the printer for output. Printers can't process raw files. But they can read the JPEGs on the card and produce prints.

So, consider all of the different ways you want to use your images, and then choose the format, or formats, which best suit your needs.

Recover Photos from an Erased Memory Card

Sooner or later it happens to just about everyone: you erase your memory card of photos you haven't uploaded yet. What a terrible feeling in the pit of your stomach when you discover this.

Fortunately, software is available that allows you to recover photos from a memory card that has been erased or formatted. Products such as Image Rescue by Lexar Media (*http://www.lexar.com*) can help you retrieve those erased pictures and upload them to your computer. (Some card manufacturers even include the software with the memory card.)

Image Rescue can work its magic because often, even though you've erased your memory card, the pictures are still on it. All erasing does is hide those photos from view and make them available for overwriting by new images as they are added to the card from the camera.

That's why the first rule of photo recovery is to stop shooting from the moment you discover that you may have erased photos you haven't uploaded yet. You want to get those latent photos before your camera overwrites them with new pictures.

Image recovery software often requires that you use a memory card reader to connect to the computer instead of your camera cable. This is a good argument for always having a reader with you, even if you have a cable on hand. Plus, if the cable becomes lost or damaged, you have a backup method to retrieve your pictures.

Image Rescue is one of the many applications available to help you retrieve pictures off an erased memory card.

To use recovery software, first launch the application and then connect your memory card. The software will scan your card and show you thumbnails of all the candidates for recovery. You'll be surprised what you see sometimes. In addition to shots you accidentally erased, you may see some "oldies" on the card that somehow haven't been overwritten yet. That's why if you ever lose an image on your computer, you should try to retrieve it from your memory card. You never know; it might be there.

Once you select the images you want to save, the software will download copies off the card and write them to your computer. This process works well and is easy enough for even first-timers.

You may have other tools available to you too, such as a software tester to report on the integrity of the memory card. I've seen DVD-burning software included sometimes that lets you transfer saved images directly to an optical disc. And if you really want to wipe all data off a card so that it can't be recovered, you can use the card formatter sometimes available with recovery software.

The bottom line is to be prepared for accidents before they strike. Have image recovery software loaded on your computer and have a memory card reader on hand. That way, an erased picture won't become a lost one.

Archive Images for Future Use

You should treat digital images like any other important computer files: archive them and keep them in a safe place. Most computers have built-in optical drives for burning compact discs and DVDs, both of which are reasonable archiving media. If you use optical discs for archiving, consider making two sets of backups—one for your home, and another to be kept in a remote location—just in case one set gets damaged.

Another archiving approach, and one that is easier to manage than using optical media, is to save your pictures to external hard drives. The advantages of external drives over optical media are that they have greater capacity (250 GB and upward), have faster read/write times, and are easier to catalog.

If you really want to cover all the bases, back up your images onto two external hard drives and store them in different locations—one at home and another at the office. That way, not only are you protected if one drive fails, as hard drives sometimes do, but you also don't have to worry about losing your pictures if there is fire or water damage at one of the locations.

Risk factor	Archive strategy	Peace-of-mind quotient
Extreme; photos are vulnerable to loss	None; all images reside on the computer hard drive	0; no peace of mind
High	Some photos backed up on a hard drive somewhere	2; will recover some images after a computer crash, but not sure how many or what they are
Moderate	Have all photos backed up to single hard drive in same location as computer	5; protected from computer crash, but not from theft, fire, or flooding
Low	Hard drive backup at computer location, plus second hard drive with same data at remote location	7; protected from computer crash, theft, fire, and flooding
Minimal	Hard drive backup at computer location, second hard drive with same data at remote location, DVDs containing best images at third location	9; protected from computer crash, theft, fire, flooding, and hard drive failure

Degree-of-anal-retentiveness back-up guide

Some photographers like to use external hard drives for backing up at home, and then save their most valuable images to optical media for storage at a remote location. This hybrid system strikes a good balance between convenience and reliability. The super-fastidious (this is my category) should think about a system that uses two sets of external hard drives in separate locations, plus one set of optical media in a third place. Does that sound a little over the top? Well, how important are your pictures to you?

Regardless of which media you use, when preparing to back up your photos, take a few minutes to figure out how you want to organize the files before you copy them to your backup media. Since digital cameras usually assign names such as *IMG_3298.jpg* to your pictures, you won't be able to go back and find those Paris shots by reading the filenames. Yet, you're probably not going to want to rename each picture individually, either.

Instead, give a descriptive name to the folder that contains images of a like kind, such as Paris Trip 2002. You can always browse the contents of the folder with an image browser once you're in the general vicinity.

TIP ▼

If you're using photo management software such as Adobe Lightroom or Apple Aperture, you have the ability to rename files when you upload the files to the computer from your camera. I recommend that you keep the file number as part of your custom naming convention, such as *europe_3298.jpg*. This will help you keep track of specific images regardless of whether they are backed up and stored in remote locations, or right there in your photo management software.

No matter which method you embrace, the important thing is to have an orderly system and a regular backup routine. You already know how frustrating it is to look for an old picture buried in a shoebox deep within your closet. Consider digital photography your second chance in life, and take advantage of your computer's ability to store and retrieve information.

TIP ▼

Mac users may want to investigate Time Machine, which is a component included in Mac OS X 10.5 Leopard. Time Machine enables users to set automatic backup routines that write only new files or files that have changed. This could be useful for photographers using the Mac platform. Also, for more information on managing digital photographs, especially on a professional level, see *The DAM Book: Digital Asset Management for Photographers*, by Peter Krogh (O'Reilly).

Manage Movies Made with a Digital Camera

If you've followed the evolution of consumer digital cameras, you know that manufacturers have really improved these palm-size devices' ability to capture high-quality video. The advantage for you is having just one device to take still pictures and capture life in motion as it breezes by.

In Chapter 2, I provided lots of tips for recording movies with your camera. The challenge is what do you do with them after that? If you thought backing up your photographs was resource-intensive, just wait until you start creating those multimegabyte movies.

External hard drives have become much more affordable and have tremendous storage capacity. I think they are the best solution for movie archiving. If you've created a robust archiving system with external drives for your photos, you should be able to adapt it to your movies as well.

Type of user	Suggested software	Degree of retrievability
Birthday party parent; occasional capture	Computer Finder with movies stored in dated folders	Fair, if folders are labeled consistently and there aren't too many movies to keep track of
Budding filmmaker	Apple iPhoto or Adobe Bridge	Good; movies are easily organized and can have user-added metadata to aid in retrieval
Movie maven	Microsoft Expression Media	High; robust database solution with plenty of metadata and playback options

Movie management solutions

For those who don't want to use movie management software, create easy-to-remember names for the folders you store your movies in, and give them their own location on the hard drive so that you don't have photos and movies mixed in together.

You can also use software to help you keep movies organized. Adobe Bridge (Mac and Windows), which is bundled with Adobe Photoshop CS2 and later, allows you to browse thumbnails and preview movies you have stored in a folder. This is more convenient than opening each movie to discover its contents.

Apple's iPhoto (Mac) is an excellent movie manager. In addition to enabling playback via QuickTime, iPhoto lets you add keywords and descriptions, and create custom albums for storage. It's an excellent way to organize and enjoy the video you capture.

By spending the extra time to safely store this content, you'll ensure that others will be able to enjoy your movies for generations to come.

Stitch Together Video Clips into Short Movies

Often, the difference between an interesting home movie and one that's intolerable is how well it's edited. This applies to the video you capture with your digital camera as well. Chances are your digicam came bundled with software to help you edit your movies. If it didn't, or if you don't like that software, you can use QuickTime Pro and just a few simple commands to transform your video clips into short movies.

Many digital media fans are already familiar with QuickTime. The free player is available for Windows and Macintosh computers, and chances are you already have it on yours. If so, you can use it to watch the video snippets you capture with your digital camera.

You can purchase a registration key for $30 from the QuickTime website (*http://www.apple.com/quicktime/*) that unlocks a number of additional powerful features, including:

Editing tools You can trim off excess footage, combine clips together, add soundtracks, rotate them 90 degrees, and create titles for your movies.

Full-screen playback You can turn your computer into a movie theater that presents your videos in full-screen mode with a black background. It's very impressive.

Additional audio and video controls You can fine-tune playback by adjusting brightness, treble, and bass using the advanced controls.

I'm going to introduce you to two powerful editing techniques in QuickTime Pro. (This is the Swiss Army knife approach for those who don't want a dedicated movie editor such as Apple's iMovie for the Mac or Adobe's Premiere Elements for Windows.) First you will learn how to trim your snippets to cut off excess footage you don't need. Then you'll use the Select, Copy, and Add commands to combine your video clips into short movies. Here's how it works:

1. Upload all of your video snippets from your digital camera, and then open the two clips that you'd like to combine into one short movie by double-clicking on their file icons or by using the Open command in QuickTime. Place them side by side.

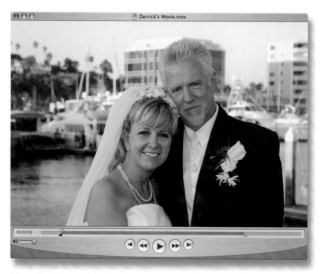

Trimming video clips is easy in QuickTime Pro. Drag the two bottom indicators to select the footage you want to keep. Then select Trim to Selection from the Edit menu at the top of the frame to discard the footage before and after those markers.

2. Use the Trim command to snip off unwanted footage at either end of your movie. Simply move the bottom triangles on the scrubber bar to the endpoints of the content you want to keep, as shown in the following figure. The gray area will be kept, and the white area on the scrubber bar will be trimmed away. To make this happen, go to the Edit drop-down menu and select Trim to Selection. Repeat this process for both clips.

3. Now use Select All, Copy, and Add to Movie to combine these short clips into a longer presentation. The procedure is similar to copying and pasting in a text document, but with a slight twist. Start by going to your first snippet and clicking on the far-right control button to move the scrubber head to the end of the clip. (You could manually drag the scrubber head there, but this way is faster.)

4. Next, click on the second movie once to bring it forward. You're going to copy the content of this snippet and add it to the window on the left. Open the Edit drop-down menu, choose Select All, and then open the menu again and select Copy. That will put the selected video and audio on the clipboard.

5. Finally, click on the first window once to bring it forward, and choose Add from the Edit drop-down menu.

6. The video you previously copied to the clipboard will be added to the end of your first snippet. Notice how the time designation has changed to reflect the addition of the second snippet.

Remember that I mentioned this procedure is like copying and pasting text, but with a twist? You could use the Paste command here too, but doing so would replace the video in the left-hand window, instead of adding to it. That's the twist in QuickTime Pro.

If you want to combine more than two clips, you can keep adding snippets as described in the preceding steps until you have a complete movie. Always work from the beginning of the movie to the end, adding video clip after video clip, and be sure to trim your snippets before adding them to the movie.

Once you've combined your clips into one movie, go to the File menu and select Save As. Give your movie a new name, click the "Save as a self-contained movie" radio button, and then click the Save button. You now have a complete movie.

These simple editing maneuvers allow you to combine as many snippets as you want to build home movies. Keep in mind that you should use the same pixel dimensions, such as 640×480, for all of the clips that you'll use to create the final presentation. Otherwise, parts of your movie won't look right.

When you save your movie, be sure to select "Save as a self-contained movie" so that all of the assets are included in the file.

Process HDR Images in Photoshop

In Chapter 3, I showed you how to capture a series of photos for later merging into a single HDR image with Photoshop. Now it's time to take that raw material and create a stunning image.

Upload the pictures to your computer. Open Photoshop CS2 or later and go to File→Automate→Merge to HDR. Click on the Browse button and navigate to your bracketed images. If you didn't use a tripod when shooting, select the Attempt to Automatically Align Source Images option. Then click OK.

After processing the images, Photoshop displays a preview window of your merged image. On the left side of the window, you'll see your source frames with their exposure values listed beneath them. On the right you have a slider that lets you review the image's entire dynamic range. Why can't you see all the tones at once? The Merge to HDR command creates a 32-bit image—that's quite a bit more color information than your 8-bit monitor can display at any one time. The slider lets you view this color information in degrees. However, the slider is for viewing purposes only. You're not making any changes here.

Before you move on, you need to choose a bit depth for your final image using the drop-down menu above the histogram. I recommend selecting 16-bit/Channel. A 16-bit image will retain more information than you would get with an 8-bit image, while still giving you the flexibility to fine-tune the image with Levels, Curves, Color Balance, and similar controls—something you can't currently do with a 32-bit image. (Frankly, you can't do much with 32-bit images at the moment since they don't display properly on regular monitors, nor do they print well.)

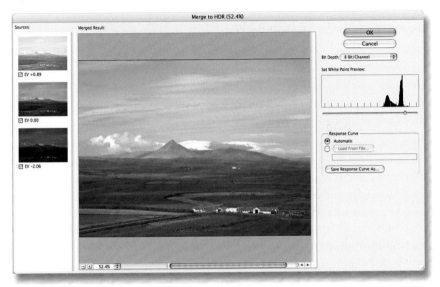

Here's a Merge to HDR in progress. The merged image in the center incorporates tonal information from the three frames on the left. If the final output is going to be to JPEG, I could leave the bit depth at 8. But since I'm saving this as a master TIFF file, I'm going to change it to 16-Bit/Channel.

When you click OK, Photoshop begins to create the merged file. At this stage, you have more image information than you can really use, so you need to tell Photoshop what to do with that extra data. In the HDR Conversion dialog box, you have a choice of four different conversion methods. If you're relatively new to HDR imaging, I recommend first trying the Equalize Histogram method. It attempts to automatically compress the broad dynamic range of the HDR image in a visually pleasing way. Don't worry if your picture still appears a bit flat; you'll have a chance to punch it up later.

Next, I recommend that you choose Exposure and Gamma from the Method pull-down menu. This lets you use two adjustment sliders to fine-tune your picture.

When you're done, click OK, and Photoshop will do additional processing and present you with an untitled 16-bit HDR image. Save it as a Photoshop file. Now you can spruce up your picture with your favorite controls, such as Levels, Hue/Saturation, Curves, and Unsharp Mask. When you're done, save the image again, keeping it as a Photoshop file. This becomes your master print. If you need to use your image in screen presentations, such as a slide show or a web page, use the Save As command to create JPEG duplicates.

Convert Color Pictures to B&W

Even though digital cameras can shoot just fine in B&W mode, for the best quality I recommend that you capture in color and then convert your images to B&W on the computer. This is an easy process that lets you have both versions of the file, ensuring that you have maximum flexibility when it comes time for output. Nearly every photo management application provides you with this option.

Once you have your pictures uploaded to the computer, open your favorite image editor and look for the option that enables you to convert to B&W. This is an option that should be available regardless of the application you're using. But I do like the converters in some image editors better than others. I'm going to walk you through a few of my favorite applications here.

B&W in Photoshop CS3

If you're using Photoshop CS3 (Mac and Windows) go to Image→Adjustments→Black & White. You can click the Auto button to let Photoshop take the initial stab at the conversion, and then manually adjust the sliders to suit your taste. You might also want to sample the variety of predesigned settings listed in the Presets pop-up menu. Traditional B&W photographers will recognize the yellow, orange, and red filter presets. Once you've settled on the look you want, click OK and Photoshop will finish processing your shot. You can now use Levels, Curves, and other Photoshop tools to fine-tune your image. Be sure to Save As when you're finished so that you don't overwrite the original color photo.

B&W in iPhoto

Apple's iPhoto (Mac) simplifies this process even more. Start by opening your photo in Edit mode. Then click on the Effects button at the bottom of the window. You're presented with a grid of nine thumbnails that display previews of the various filters for your photo. B&W, Sepia, and Antique are all great options for monochrome effects. Just click on the button you want, and iPhoto applies the filter. If you decide you don't like the way the image looks, simply go to Edit→Undo to return the image to its full-color glory. You can also continue working on your image after conversion by opening the Adjust panel and playing with the Exposure, Brightness, Contrast, and other sliders.

Type of artist	Suggested software	Anticipated results
Novice	Don't use any; just shoot in B&W mode on camera	Fair; cameras do a decent job, but few options later in postproduction
Aficionado	B&W presets in iPhoto or Lightroom	Simple one-click conversions produce pleasing results capable of making nice prints
Approaching Adams	Grayscale conversion tools in Adobe Camera Raw, Photoshop CS3, Apple Aperture, and Adobe Lightroom	Capable of superb results rivaling traditional chemical process, especially when output to capable B&W printers

Going grayscale

B&W in Lightroom

I think the best method in Adobe Lightroom is to open your picture in the Develop module, and then click on the Grayscale label in the HSL / Color / Grayscale panel. You can adjust the tonal mix of your image by moving the Grayscale Mix sliders to the left and right. You may also want to use the Target Adjustment tool and adjust specific tones in the image by dragging the tool up and down on the areas you want lighter or darker.

In Lightroom, you can make a virtual copy of your original color photo and then convert the copy to B&W using the advanced tools in the Develop module.

You Make the Call

As you can see from this small sampling of imaging applications, B&W conversion and adjustment is a straightforward process in postproduction. Test the method you choose by making prints and comparing them to B&W images you like. With a little trial and error, you can develop a workflow that is efficient and produces attractive grayscale images.

TIP ▼

Do you like the look of B&W film and wish you could create that effect with your digital images? You can. Exposure 2 by Alien Skin (*http://www.alienskin.com*) is a Photoshop plug-in that features more than 300 presets that let you simulate nearly every film stock ever created, including one of my all-time B&W favorites, Kodak TRI-X 400.

Photo Management Applications

Photoshop is often the first, and sometimes the only, photo application that photographers investigate to help them manage their work. But at its heart, Photoshop is essentially an image editor primarily designed to adjust pixels. True, over the years it has expanded its scope beyond curves and levels into a program that lets you merge elements to create entirely new pictures. Photographers need the types of tools Photoshop has to offer, for sure. But they also need to organize their work, mark the best images, add bits of metadata to them, and output to a variety of media, including slide shows and web pages.

The current generation of photo management applications addresses these tasks. And depending on the ones you choose, they can handle the bulk of your photography work—including image editing.

This section provides you with an overview of the photo software that I consider among the best. Take a look at what's offered here, and consider fine-tuning your workflow so that you're spending the bulk of your time on things you want to do, instead of combing your hard drive for that portrait you took a year ago while traveling abroad.

> **DEFINITION ▼**
>
> Image editing versus photo editing: these two functions may sound similar, but they are actually quite different. Image editing is the act of adjusting pixels to improve contrast, fine-tune color balance, sharpen, and perform a host of other tasks. Photo editing is the art of sifting through your pictures to find the best shots. In the past, photo editing was often done on a light table with a magnifying glass. Today most photographers use their computer monitor as a virtual light table.

Apple iPhoto

Apple iPhoto ships on every Mac sold, and for many hobbyist photographers, it's the only photo management tool they will ever need.

Over the years, iPhoto has matured nicely. It supports sophisticated importing options that aren't quite as powerful as those included with Aperture and Lightroom, but are certainly as feature-rich as most amateurs will want. Once the pictures are tucked away in the iPhoto Library, you can rate pictures, add keywords, type descriptions, adjust picture appearance, and output to an incredible array of media.

In fact, output is where iPhoto really shines. Its slide show authoring tools are top-notch and are integrated with iDVD so that you can create your own discs playable on virtually any DVD player. Photographers who also have Apple's .Mac service enjoy

streamlined web authoring that requires just a few clicks to create professional-looking online galleries.

Thanks to direct connection with Kodak's online services, you can also order prints, calendars, hard-bound books, and greeting cards all from within iPhoto's friendly user environment.

Apple's iPhoto is a great example of a photo application that combines ease of use with lots of features.

If you need to make a few image adjustments before ordering your custom note cards, iPhoto provides the essential global tools including levels, shadow and highlight recovery, sharpening, and color correction.

Even though iPhoto is a nondestructive environment (your originals are always safe from degradation), it isn't quite as metadata-savvy as Aperture and Lightroom. You don't have versions or virtual copies. And even though iPhoto does an admirable job with raw files, if you're a heavy RAW shooter, you'll probably want to look at Aperture before too long.

The good news is that Aperture and iPhoto play nice together. If Aperture becomes your primary image bank, you can access that library through iPhoto and still enjoy all of its wonderful output options.

So, iPhoto works beautifully as a standalone application and can also serve as the world's coolest photo plug-in for Aperture.

One area where it trumps its bigger brother is the handling of movie files recorded with your digital camera. iPhoto can catalog those files, including keywords and descriptions, right alongside still photos. If you like to capture video with your digicam, iPhoto becomes even more useful.

Key benefits include an attractive, intuitive interface, a short learning curve, a wide array of output options, incremental backup for Mac OS X 10.5 users (via Time Machine), movie handling as well as still photos, compatibility with other Apple apps, and low cost. (As noted earlier, it comes bundled on every Mac sold.)

Adobe Photoshop Elements

Adobe Photoshop Elements has borrowed a page from the Lightroom modular approach. Its four work areas—Organize, Edit, Create, and Share—divide the workflow into basic tasks.

Beyond that, Elements provides snapshooters with step-by-step assistance by enabling them to simply choose the task they want to perform, such as touch up a photo, and then click on the Guided button. Users are then escorted through each step in the correct order.

Adobe Photoshop Elements combines great technology
with a user-friendly environment.

The Organize section will introduce amateur photographers to keywording and smart albums. You can quickly tag your images and then search on those tags to find the pictures that fit those criteria. Smart albums automate this process by pulling together collections of images into albums based on your preferences. The feature is very convenient and works well.

The editing tools are good, as you would expect from Adobe. Something I found surprising was that Adobe included some of the most advanced technologies from its professional applications into Photoshop Elements. For example, you can use Photomerge to combine the best expressions from two family group shots. You'd think this would require a lot of precision on your part, but it's as simple as drawing a circle around the face you want to include.

Scrapbookers will enjoy many of the tools in the Create work area. In fact, Elements for Windows is a terrific choice for people who make scrapbooks. You can also make other goodies such as DVD labels and greeting cards.

Adobe integrated a healthy dose of its Flash technology into the Share area. You can design web pages that rival professional sites with Flash effects built right in. You can also connect to online services to order prints and books.

Overall, Photoshop Elements is the complete work environment for photographers using XP or Vista. I recommend it as the leading consumer photography application on the Windows platform, comparable to what Mac users have in iPhoto.

Key benefits include a helpful modal approach to guide users through the workflow, solid image editing tools, lots of creative options for scrapbookers, and advanced technologies such as Photomerge.

DEFINITION ▼

Global image editing vs. localized editing: by understanding these two basic types of image editing, you can better evaluate the power of applications that use one or the other approach. Global image editors let you make changes to the entire photograph. So, if you adjust the photo's contrast, it is applied to the overall image.

Localized editing allows you to work on a specific area, such as tweaking the contrast for the sky alone while not affecting the other elements in the photo.

Global editors may support some area-specific corrections, such as eliminating dust spots, but for the most part, their strength is in adjusting the overall image.

Adobe Bridge

Bridge (Mac and Windows) is a file browser that's bundled with Photoshop CS2 and later. When you buy Photoshop, Bridge is in the box.

Bridge enables you to upload pictures from your memory card, rate pictures, and add IPTC metadata and keywords. Even though Bridge doesn't support image editing, it does work closely with Adobe Camera Raw (ACR) and Photoshop. So, double-clicking on a thumbnail in Bridge can lead to opening that image in either image editor, then returning to Bridge once the adjustment has been made.

You can create slide shows on the fly in Bridge, but if you want to save those presentations to your hard drive, make prints, or build web pages, you have to go through another application such as Photoshop.

Bridge is an appealing organizational tool for many photographers. Photoshop users already have it loaded on their hard drive, so there is no additional cost. You can store the images on your computer or an external drive and simply point to them with Bridge, making it a very flexible tool. You can even use Bridge to browse pictures on your memory card before actually uploading them to your computer. And because it's so tightly integrated with Photoshop and ACR, you can build your own photo management workflow with Bridge.

Adobe Bridge provides a wealth of information in a well-organized user interface.

BRIDGE AND ADOBE CAMERA RAW

When you buy Photoshop CS3 or Photoshop Elements, you not only get Bridge, but you also get a version of Adobe Camera Raw (Mac and Windows). And you can run ACR via Bridge without ever launching Photoshop. At its heart, ACR is a processor that lets you convert the raw data your camera captures into a completed photograph. In a sense, it is a specialized image editor.

The most powerful version is 2.0 or later because a number of innovations were introduced at that stage, including new highlight and shadow recovery tools, excellent controls for B&W processing, the ability to handle JPEGs and TIFFs in addition to raw files, built-in healing and red eye tools, independent toning of highlights and shadows, alluring adjustments such as Clarity and Vibrance, and an improved, easy-to-understand interface.

From Bridge, you have the option of opening an image in
Adobe Camera Raw without ever launching Photoshop.

Keep in mind that ACR has to work in conjunction with at least one other application, such as Photoshop or Bridge. You can't print from this application, organize images, add metadata, or back up your files. But ACR is not designed to stand alone. Rather, it is a specialized tool that's designed to efficiently handle the common image edits that all photographers need to make. A common workflow is to use Bridge, ACR, and Photoshop as a trio. Bridge serves as the file organizer, ACR enables raw decoding and global image editing, and Photoshop is used for special projects and localized edits.

Bridge handles a wide variety of file types too. You can browse JPEGs, TIFFs, Photoshop files, raw files, and many types of video. The compatibility with movie files is notable because these are not supported in Adobe Lightroom and Apple Aperture.

There are a few holes, however, when comparing Bridge to those more integrated photo managers. Bridge does not have incremental backup. So, you have to make sure you handle archiving on your own, or use a separate application. Also, you don't have virtual copies in Bridge, so if you want multiple versions of a picture, you have to make full-resolution duplicates.

With that being said, you can't beat the price of Bridge, especially if you have to upgrade to the latest version of Photoshop anyway. And with a little planning, you can shape a fairly powerful workflow around it. Plus, I already alluded to the one thing that Bridge can do which Lightroom cannot: it can organize and even preview video captured with your digital camera. This is an important function if you regularly capture video with your compact digicam.

Key benefits include an attractive interface, easy file browsing, a wide variety of media compatibility including movie files, and plenty of metadata options.

Adobe Photoshop Lightroom

For many photographers, especially those who shoot raw and want a more integrated environment for postprocessing, Adobe Photoshop Lightroom (Mac and Windows) may be the perfect solution.

Lightroom takes your photos directly off the memory card and provides a modular environment to manage, process, and output your pictures. Its five modules—Library, Develop, Web, Slideshow, and Print—are organized to pull you through the workflow so that you can concentrate on making great pictures, not on trying to figure out how to use the application.

The process begins with the Import Photos command that lets you upload images from your camera, hard drive, or even another Lightroom Catalog. In the Import dialog box, you can rename your files, add keywords, and add your personal metadata such as copyright information. Before you know it, they have been integrated into your Lightroom Catalog.

Once your pictures are uploaded, you can organize them in the Library module. Here you can add star ratings to make it easier to identify your best shots. You may want to create a collection that allows you to group images. And if you'd like, you can write captions and add more keywords to help you easily retrieve your images down the road.

Adobe Lightroom is a total photo management solution.

To fine-tune the appearance of a photo, click on it and then move to the Develop module. Here you have a variety of powerful image editing controls that make it easy to adjust tone and color. Once your photo looks right, you can move to one of the output modules—Web, Slideshow, or Print—to prepare your picture for sharing with the world.

Typically, the photographers I talk to who prefer Lightroom to other top-drawer photo management applications are shooters who are comfortable with the Adobe approach to software design. Lightroom is easier to use than Photoshop, but it has many of the same controls. Also, people who like to have the postproduction workflow laid out for them also seem to resonate with Lightroom.

You don't have to be a RAW shooter (it handles a variety of file formats), but for those who need a cross-platform solution that's compatible with dozens of raw formats, Lightroom should be on the short list of considered options.

Key benefits include smooth handling of raw files, nondestructive editing, the ability to make virtual copies of large files without duplicating them, a flexible backup capability, cross-platform capability, excellent image-editing controls, the ability to integrate well with other Adobe applications, and broad camera support.

Microsoft Expression Media

Microsoft's Expression Media (Mac and Windows) is the only true digital asset manager of this collection. It can organize more than 100 different formats, including raw files and movies. But where it really shines is retrieving that data quickly. If you are given the task to set up a library of digital media, one of your first stops should be at Expression Media's doorstep.

In addition to powerful search capability, Expression has batch processing and some slick automation tools such as Watch Folders that are automatically updated with images that fit their established criteria.

If you purchase the companion application, Expression Encoder, you can author professional slide shows, web galleries, and video, taking advantage of its attractive bundled templates.

Expression Media and Encoder can be the cornerstones of a digital asset management workflow. Just add your favorite image editor, and you can organize something as large as the local library or as personal as years of your own work.

Key benefits include powerful tagging and search features. Also, the batch processing is excellent, you have an array of output options, and the software provides excellent cross-platform offerings.

Apple Aperture

High-volume shooters who cover sporting events or weddings or who are often on location will appreciate Aperture's robust photo management tools that make it easier to organize thousands of images. Aperture (Mac only) is designed for the working pro, but it is often embraced by snap-happy digital shooters who have mountains of pictures to keep track of.

Aperture is similar to Lightroom in its intelligent handling of raw files. Once you've imported the image into the application, all adjustments and versions of the photo are stored as tiny data files. So, if you decide that you'd like a B&W version of a 12 MB photo, it will add only a few kilobytes of data to your hard drive. When it's time to output the picture, Aperture reads the master file, applies the data instructions, and renders a high-quality photograph.

Also similar to Lightroom, Aperture handles a variety of file formats in addition to raw, so it's just as beneficial to JPEG shooters. But unlike Lightroom, Aperture is far less modal. It uses versatile Heads-Up Display (HUD) that enable you to make image edits anywhere in the application.

*Apple's Aperture is the professional photo management
application that will also appeal to snap-happy amateurs.*

DEFINITION ▼

I'm going to define *modal workflow* as it applies to Lightroom and doesn't apply to Aperture. Lightroom is considered to be a modal application because it has modes for the various steps in the workflow. If you want to organize a picture, you go into Library mode. To adjust its exposure, you go to Develop mode. Aperture, on the other hand, doesn't confine you to modes. You can, for example, adjust exposure regardless of where you are in the application or what you are doing. Just call up the Heads-Up Display, make your adjustment, and then go back to what you were doing.

Aperture also supports dual-monitor display, features an outstanding full-screen mode, has solid slide show authoring, and really shines with its incredible organizational tools.

All of this power does come at a price, however. Aperture users need fairly current Mac hardware for the best user experience. Also, be sure to check the Aperture website (*http://www.apple.com/aperture*) to ensure that the software supports your camera's raw files.

Key benefits include smooth handling of raw files, nondestructive editing, the ability to make versions of large files without duplicating them, dual-monitor support, powerful organizing tools, an elegant user interface, an option for reference files or managed libraries, seamless integration with other Apple applications, instant online photo galleries for .Mac members, and incremental backup for managed library users.

Gearing Up

Now it's time to make a few decisions. The easiest way to go is to buy a new computer, add the latest photo management software of your choice, and build a workflow that you enjoy and can maintain. All you need now is the right software that suits your tastes and needs. In addition to the descriptions in this chapter, the following table provides a quick reference for some of our favorite photo applications.

But you may not have that option just now. If you're on a Mac, take a look at iPhoto and see how close it comes to meeting your needs. It's an excellent application that supports most tasks amateur photographers need to perform. If you find yourself wanting more capability, consider Aperture or Lightroom.

Windows users should consider the latest version of Photoshop Elements as their starting point. It melds tremendous capability with a user-friendly environment. And it's affordable. If you find you're ready for more horsepower on a Windows machine, I recommend Lightroom as the next step.

The current Photoshop orbits around its own sun. People who need its advanced image editing tools (such as localized adjustments) can rarely survive with anything else. But it includes some slick workflow components (Bridge and ACR) that can also fill your needs, especially if your credit card is maxed out from Photoshop's steep price tag. If you don't want to go back over all this text, take a look at the table on the next page that provides a convenient wrap-up of all the major features of each of these applications.

So, consider your primary needs, your preferred shooting format (JPEG or raw), your hardware capability, and your wallet. Then use the information in this chapter to build the best workflow for you. Once you do, your enjoyment of photography will grow in leaps and bounds.

Where to Go from Here

Now that you have a collection of hand-picked, carefully crafted images, why not take the next step and commit them to paper? In Chapter 5, I'll show you how to easily make prints that you'll be proud to display for all the world to enjoy.

	Platform	File types	Metadata	Image editing	Photo editing
Elements	Mac/ Windows	Raw, JPEG, TIFF, PSD, DNG	Yes	Yes	Yes
Photoshop CS3 (includes Bridge and ACR)	Mac/ Windows	JPEG, TIFF, PSD, (raw, DNG via ACR), Movie, AVI, MPEG (via Bridge)	Yes via Bridge, limited via Photoshop proper	Yes	Yes via Bridge
Lightroom	Mac/ Windows	Raw, JPEG, TIFF, PSD, DNG	Yes	Yes	Yes
iPhoto	Mac only	Raw, JPEG, TIFF, PSD, Movie, AVI, MPEG	Yes	Yes	Yes
Aperture	Mac only	Raw, JPEG, TIFF, PSD	Yes	Yes	Yes
Expression Media	Mac/ Windows	Raw, JPEG, TIFF, PSD, Movie	Yes	No	Yes

Round-up of photo management application feature highlights

Printing	Slide show	Web pages`	Backup	Best suited	Approximate price
Yes	Yes	Yes	Yes	Beginner, intermediate	$99
Yes	Yes	Yes	Yes	Intermediate, advanced amateur/pro	$649
Yes	Yes	Yes	Yes	Intermediate	$299
Yes	Yes	Yes	Yes, with Leopard		Bundled with Mac, or $79 as part of iLife
Yes	Yes	Yes	Yes	Intermediate, advanced amateur/pro	$299
Yes	Yes	Yes, with add-on application	Yes	Intermediate, advanced amateur/pro	$299

Printing Made Easy

SIMPLE SETUPS FOR BUSY PHOTOGRAPHERS

Ah, printing, the final frontier for many hobbyist photographers. Some view it as the ultimate demonstration of their photographic prowess. Personally, I don't recommend that you put so much pressure on yourself. It's true that 100 years from now, a print could be a remembrance of your photography that someone might discover in an attic or among your stored belongings. Prints tend to survive. And that's part of the reason I think we should learn more about the process.

Prints are also beautiful. You can hold a print, feel the texture of its surface, mount it on the wall, or just let it sit quietly on a table, beckoning those passing by to lift it into their hands. This is artwork that we can make.

And the good news is that all of this beauty doesn't have to come out of pain, because printing can be simple too. Yes, later on, you may want to refine your workflow to get that extra 10% of precision. But for now, the real goal is to get you printing and producing great-looking stuff. And that's exactly what we're going to do in this chapter.

Fresh Approach to Printing

Printmaking falls into two basic categories: prints you make yourself and those that are commercially produced by a service. Regardless of the final destination, you need to follow a few basic steps to ensure success.

The journey begins with figuring out your best images. One of the blessings of digital photography is that we don't need to print every picture we take. We shoot lots and lots with a camera, find the best shots on the memory card, perfect them on the computer, and then choose just a handful for output to paper.

After photographing a birthday party, for example, you don't need two hundred 4×6-inch snapshots lying around the house. That's what web pages are for. Figure out which half dozen images truly capture the essence of the event, and print those. By taking this approach, you will save money and focus your energy on the images that have the most potential.

To get the results you want, however, you need a system. Don't be deterred by the concept of "workflow." I said that you need a system; I didn't say that it has to be hard. In fact, I'm going to show you three different approaches that vary from mind-bendingly easy to deceptively simple. You pick the approach that best fits your needs at the moment. And the best part is that all three approaches result in good prints.

Approach 1: Direct Printing

For some people, the computer literally sucks the joy out of their photography. I've heard folks say, "I want to switch to digital, but I hate using computers." And to tell you the truth, I understand why. When we take pictures, we are directly interacting with our environment. Sometimes we simply want to see the moment, capture the moment, and replay the moment. In this scenario, computers can often kill the moment. They interrupt the flow. It's like the phone ringing just as you sit down to dinner.

For these occasions, direct printing might be the way to go. You take the picture with your digital camera, find the one you like on its LCD, and then make a print of it.

"Wait a minute," you may be thinking. "How did you bypass the computer?" Well, you don't need it. There are many terrific printers on the market that allow you to connect your camera directly to them—no computer required. And some of these models, such as the HP Photosmart A620 (*http://www.hp.com*), let you remove your memory card from the camera, insert it into the printer, and set up your job on a handsome LCD screen that's right there on the printer. You can make professional-looking borderless prints, and if you need to, you can even make minor image edits without ever touching a computer. Here are the basic steps for this type of direct printing:

1. Capture the best images possible with your camera.

2. Power up the printer and load the paper.

3. Take the memory card out of your camera and insert it into the printer.

4. Choose the image you want to output from the printer's LCD screen.

5. Tap the Print button.

About 90 seconds later, a full-color, borderless print will emerge from the unit. If you like the way it looks, you're done. If it needs a little tweaking, study the print, make the adjustments on the LCD, and hit Print again. With very little practice, you'll learn how to adjust your images for the type of prints you like.

The HP Photosmart A626 printer allows you to connect your camera directly, or insert its memory card to create prints up to 5×7 inches.

There are a few things to keep in mind to improve your success. First, start with photo paper that is matched to your printer. You don't have many opportunities for calibrating color with this approach, so keep things simple. Choose the paper designed for the printer, check in the printer's menu settings that the right paper is selected, and then print.

Also note that these printers can handle only JPEGs. If you're a raw shooter, go to your camera's setup menu and select RAW+JPEG. You'll capture in both formats now: JPEG for making your direct prints and raw for more detailed work down the road.

If you want to take your printer on the road, many devices have rechargeable batteries that you can purchase. Otherwise, just don't forget the power cord as your rush out the door.

And finally, study the owner's manual that comes with the printer. Units such as the HP A620 have a bounty of fun features—such as being able to add specialty borders to your prints—which you wouldn't want to pass up just because you didn't know they were there.

TIP ▼

Prints that you make "on the spot" can be the ultimate party favor at family gatherings. Plan ahead, by bringing an empty photo album or two with you. Then, select the best shots from the day, output them on your portable printer, and present them to the guest of honor. It's a gift beyond compare.

Approach 2: Order Out

You can still avoid the computer by taking your memory card to a local photo finisher and having your prints made there. I like this method, but I actually prefer using the Internet for ordering out. And yes, most people will have to use their computer for online ordering, unless you have one of those nifty Wi-Fi cameras that connect directly to a photo service.

But for the rest of us, connecting to a service via our computer allows us to make our decisions on a nice large monitor, and then place the order from the comfort of our home. A few days later, your finished work appears in the postal mailbox, or some services even allow you to pick up the prints at a local retail store.

Print services can take your digital files and output them as high-quality photos.

As simple as this workflow is, you should keep in mind that you're still introducing a new device that sits between your camera and the photo finisher: the computer. To ensure that what you see on the computer is close to what is delivered in the mail, you need to think about monitor calibration.

TIP ▼

Photo editing pays dividends when you're ready to print. By knowing ahead of time which of your shots are the best (photo editing), you can get down to business quickly when the mood to print strikes.

Basically, *calibration* means that you're adjusting the tones on your computer screen to an agreed-upon standard used by most output devices (including online photo finishers). That way, if you make an edit to your photo on the computer, chances are good that it will look similar on paper when you view the print. You can learn more about calibration by reading *Calibrate Your Monitor* later in this chapter. Once you do that, you're home free for online printing. Here are the basic steps:

1. Capture the best images possible with your camera.

2. Calibrate your computer monitor to these standards: Target Gamma, 2.2; White Point, 6500.

3. Upload your images from your camera and select your favorites.

4. Image-edit your favorites to taste. Choose the best resolution for your output size and bandwidth.

5. Upload the favorites to the online service.

6. Place your order.

You'll notice that I snuck a new technical term into step 4. *Resolution* sounds like a difficult concept, but it really isn't. All it refers to are the number of pixels that make up your picture from left to right and from bottom to top.

So, a photo from your 10-megapixel DSLR will have a resolution in the neighborhood of 3800×2500 pixels. That simply means that there are 3,800 pixels spanning the width of the image, and 2,500 pixels up and down.

If you were to send that original image file to a photo service, you'd have enough resolution to make a decent 26×17-inch print. "Whoa!" you say. "I was thinking more along the lines of a 5×7-inch print. If that's the case, you really don't need to spend the bandwidth to send up a full-size file. You may want to "sample down" a copy of the image and send that to the print service. I explain how to sample down in *Send Pictures via Email That Will Be Warmly Received* in Chapter 4.

OK, so the procedure is fairly straightforward, but what settings should you use? Take a look at the following table.

Print size	Standard quality (at 150 ppi)	High quality (at 240 ppi)
4×6 inches	600×900	960×1440
5×7 inches	750×1125	1200×1800
8×10 inches; 8×12 inches	1200×1800	1920×2880
11×14 inches	1650×2475	2640×3960
13×19 inches	1950×2925	3120×4680

Resolution settings based on desired print size and quality

The rule of thumb I propose is that you consider the size of print you're going to order now, and then choose one size up as your resampling guide. That way, if you change your mind later on and want a bigger print, you won't have to upload a new file.

Most snapshots look great at what I call "standard quality" (150 ppi). But if you're making an enlargement of a landscape scene or some other subject with fine detail, consider using the higher quality setting. That way, you'll know you're giving your output service all of the information it needs to make the best print possible.

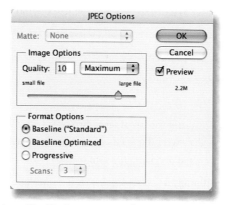

A quality setting of "10" is the sweet spot for JPEGs destined for the printer.

One other setting you might want to keep in mind when saving your resized images as JPEGs is the JPEG Quality setting. This is typically a number range between 1 and 12, with 12 being the absolute best quality. I recommend a setting of 9 or 10 for pictures you're preparing to upload to an online service; it's a nice balance between high quality and manageable file size. For my printing, I choose a quality setting of 10. I've noticed no distinguishable quality improvement at 11 or 12, but the files are much bigger.

Some people have asked me which color space online services use. Consumer services tend to be calibrated for sRGB, because that's the default color space for most compact digital cameras. You can always ask your service provider about color space, and adjust your workflow accordingly. But for the most part, if you do nothing, you should be OK.

Most online printers will charge you postage for sending the prints. So, it's best to batch your images together to keep those mailing costs down.

Also pay attention to the paper surfaces that they offer. A glossy surface is nice for snapshots and scenes with fine detail, but you may want to choose a matte or luster surface for portraits and events such as weddings. The images will have a professional look, and they won't show fingerprints as quickly as glossy surfaces.

Type of photo	Recommended paper surface	Comments
Snapshots of events, vacation, daily life	Glossy	Good, all-purpose finish that shows high detail and color saturation
Portraits	Semigloss, luster, matte	Surface texture of paper complements the subject matter
Weddings	Luster or matte	Gives images a professional appearance and surfaces don't show fingerprints as easily
Landscapes and nature (8×12 or smaller)	Glossy or semigloss	Good color saturation and detail
Landscapes and nature (11×14 or larger)	Semigloss, luster, matte	Large prints with glossy surfaces can reflect unwanted light. Textured surfaces often work better.

Recommended paper surfaces

Approach 3: Dedicated Photo Printers

Dedicated photo printers for home and studio can produce gallery-quality archive prints on a variety of surfaces. Devices such as the Epson R1800 (*http://www.epson.com*) and the HP 9180B (*http://www.hp.com*) accept paper up to 13×19 inches, enabling you to create everything from snapshots to fine art.

In the past, a certain amount of voodoo was involved in getting decent enlargements out of home printers. But thanks to improved software and an abundance of paper profiles, there's more science to printing these days than there is black magic.

Less guesswork, that is, if you know the steps to follow. With a little organization, you'll soon be churning out beautiful large-format images that can retain their integrity for decades if properly stored or displayed.

Ten Steps to Making a Beautiful Print

Some of these steps will feel familiar to you, but you'll also run across a new concept or two that we haven't discussed before, including ICC (International Color Consortium) profiles. I'll get to those in a minute. First, let's look at the basic overview for creating beautiful prints at home:

1. Capture the best images possible with your camera.

2. Calibrate your computer monitor to these standards: Target Gamma, 2.2; White Point, 6500. (See *Calibrate Your Monitor* later in this chapter.)

3. Upload your images from your camera and select your favorites (photo editing).

4. Make a copy of the files you want to print. This step mainly applies to photographers printing their originals out of Photoshop. You may find that you have to make certain color adjustments for the type of lighting in which you'll be displaying your prints. It may not be wise to make those types of adjustments to your master files. Working copies give you more latitude to experiment and adjust for specific display environments. If you're printing out of Aperture, you can instead make what are called "versions" of the images for printing, and Lightroom users can create "virtual copies."

5. Image-edit (exposure, white balance, etc.) your print files to taste. Keep your resolution at the highest dimensions possible. You probably won't be sampling down much when printing. Remember, you want to maintain your final desired output size (e.g., letter size) within a range of 150 ppi to 300 ppi.

6. Power up your printer and load the paper you want to use. While you're getting your feet wet with this process, I recommend that you use paper supplied by your printer manufacturer. (More on this later, but the quick reason is that you probably have an ICC profile for your manufacturer's paper already loaded on your computer.)

7. Open the Print Setup dialog box and make sure your printer is selected, and then choose the size of paper you want to use. You may also have to supply a few more bits of information, including the following (you can adjust to taste later):

 Position: Center

 Scale to fit media: Yes (and make sure the print resolution is 150 ppi or more)

 Color Space: Match the color space that your image was saved in. Most likely it will be sRGB. As you refine your workflow, I recommend Adobe RGB for printing at home. So, down the road, you might want to consider setting your camera to Adobe RGB, or to converting your files for printing to Adobe RGB. (Some image applications offer other color spaces that are larger than sRGB and Adobe RGB. These are worth exploring down the road.)

 Color Handling: Application Manages Colors (often this will be Photoshop) is still my favorite. But I've noticed that printers are doing a better job of color management, so you might want to experiment with Printer Manages Colors too.

Printer Profile: This is usually a pop-up menu. Look in the list for the paper stock you've loaded in your printer. These are actually specific profiles for the various papers (often ICC profiles). They are added to your system when you load the printer software.

Rendering Intent: Perceptual

Black Point Compensation: Yes

8. Hit the Print button (and wait the longest three minutes of your life).

9. Review the first print in the type of lighting in which it will most likely be displayed, such as window light, halogen, and so on. If you need to make color adjustments, return to step 5.

10. Sharpen. Once you've completed your final adjustments and you feel like the picture is ready for prime time, add a little sharpening. I recommend that you zoom out to 50% to better visualize the resolution of the print that will emerge from your printer (the monitor is 100 ppi and the print will be 150 ppi or 240 ppi). Then use Smart Sharpen if you're in Photoshop or the best sharpening filter available if you're in another application. In Smart Sharpen (Filter→Sharpen→Smart Sharpen), choose Lens Blur from the Remove pop-up menu, with a low Radius setting (1 or 1.5 pixels) and a higher Amount setting (25% or 50%). You may have to adjust to taste, but these are good starting points for making prints.

11. Make your final print. Be sure to leave it accessible after printing so that you can enjoy it and learn more about your image as you view it over time.

Printer Profiles

The most notable new concept in this workflow is the "printer profile" selection. Often, these are ICC profiles. These bundles of information help your printer match the data from your computer to the inks and paper you're going to use. Most photo printers load a set of these profiles on your computer when you install the driver. I recommend that you start with the paper sold by your printer manufacturer because those will be the profiles initially available to you.

TIP

Some independent paper stocks can be just as good as brand names for considerably less money. Kirkland Signature glossy inkjet photo paper, for example, is available for about 12 cents per letter-size sheet at discount retailers. Kirkland provides you with a guide showing you which printer profile to choose for best results. I've seen the prints and they look great.

Independent paper companies often make profiles available on the Web for their papers too. They match to the most commonly used photo printers. So, if you wanted to go that route, you would look on their site for the paper stock you're interested in, and see whether there's a profile for your printer. They will also tell you how to load the profile on your computer.

If you're truly ambitious, you can make your own profiles using systems sold by companies such as X-rite that specialize in color calibration. To start, however, I recommend that you stick with stock profiles available with your printer software or online.

Matching the correct printer profile to your paper and ink combination will give you predictable results.

Success! A Beautiful Print

Now, here's the good news. If your computer screen is calibrated and you've set up your printer as discussed earlier, you will get good prints. Keep in mind that the photo you look at on your monitor is backlit, and the image that comes out of the printer is reflective—two different types of illumination here. So, there will be differences in brightness. But with a tight workflow and a little practice, you will soon be making beautiful enlargements. Oh, and this was the most difficult of the three methods.

TIP ▼

If you have a very bright monitor, you may want to ratchet down to about one-third brightness for printing. I use an Apple 23-inch Cinema Display, and I've noticed that my prints match the screen better when I have it set to 70% brightness.

Shopping for a Desktop Photo Printer

The first thing to keep in mind when shopping for a photo printer is this: just because a model can print photos doesn't mean you'll get the results you want. Shorthand for this is: document printers are often not the best photo printers. Invest in a dedicated photo printer and you will be rewarded with consistently better output.

Here are the things I recommend you look for in a dedicated photo printer:

- A variety of compatible paper stock provided by the printer manufacturer. Look for glossy, semigloss, luster, matte, fine-art rag, and so on.

- Paper profiles available from the manufacturer for those paper stocks. Paper is no good without a profile (unless you're going to create one yourself).

- Paper profiles available from third-party paper vendors for your printer. Paper companies tend to make profiles for the most popular printers. So, it helps to get a printer that is well supported.

- An archival print rating of more than 50 years.

- The ability to print richly toned B&W images. Look for multiple black or gray inks.

- Driver software that has photo settings in its dialog box. If the Print dialog box doesn't provide you settings for fine-tuning your photo output, that's a red flag.

- Compatibility with your computer operating system and networking ports.

In addition to these features, I like photo printers that have individual ink cartridges for each color. That way, you're replacing only the ink that's depleted. One feature I've noticed on printers I like is that they have more than one black ink cartridge. Look for black, light

gray, and so on. I also like printers that have more than one option for connecting to my computer, such as USB 2 and FireWire, or Ethernet. You may not get all of these features in a model you can afford, but you should keep them in mind while shopping.

Examples of desktop photo printers that I've recommended include:

- Epson Stylus Photo R380 (letter size, less than $150)

- Epson Stylus Photo 1400 (13×19 inches, less than $350)

- Canon Pixma Pro9000 (13×19 inches, less than $450)

- HP Photosmart B9180 (up to 13×19 inches, less than $500)

- Canon Pixma Pro9500 (up to 13×19 inches, less than $750)

- Epson Stylus Photo R2400 (up to 13×19 inches, less than $800)

- Epson Stylus Pro 3800 (up to 17×22 inches, less than $1,500)

If you're not yet financially ready for a dedicated desktop photo printer, you still have many options available to you. I suggest that you get a dedicated 4- or 5-inch photo-quality printer for your snapshots (up to 5×7 inches) at home, and then use printing services for your bigger enlargements. These printers are also good for making test prints at home to get a feel for what you might expect when your online service delivers the larger size.

The Epson Stylus Pro 3800 is an excellent choice for fine-art and professional photographers.

Here's a table of possible scenarios to help you get your bearings. Even though I recommend all of the printer models in the table, what I'm really trying to do here is classify the printers so that you have a physical example of the type of printer I think is right for the job. Other models with similar features should work just fine.

Type of photographer	Prints 4×6 inches and/or 5×7 inches	Prints 8×10 inches and bigger
Budget-minded snapshooter	Canon Selphy CP740 Compact Photo Printer ($80, up to 4×6 inches)	Shutterfly, Smugmug, and other online or retail print services
Home hobbyist	HP Photosmart A626 Compact Photo Printer ($130, up to 5×7 inches)	Shutterfly, Smugmug, and other online or retail print services
Home enthusiast	Epson Stylus Photo R380	Epson Stylus Photo R380 ($130, up to 8.5×11 inches); retail services for larger prints
Advanced amateur	HP Photosmart A626 Compact Photo Printer ($130, up to 5×7 inches)	HP Photosmart B9180 ($500, up to 13×19 inches)
Part-time pro/fine-art photographer	Shutterfly, Smugmug, and other online or retail print services	Epson Stylus Pro 3800 ($1,500, 17×22 inches)

Printer recommendations

The real advantage to these scenarios is that they provide you with simple road maps to get quality prints easily. That's the key here.

Yes, you could probably wrangle a good enlargement out of your all-purpose document printer, but you would have to run more test prints to do so, and your results probably would not be repeatable down the road. The good news is that your document printer is still exceptional at documents. And if you're on a budget, you can augment it with a compact photo printer, and you're done.

But if you want photo-quality, archival, big prints that are easy to produce, I recommend a good desktop printer that will cost you $350 or more.

Calibrate Your Monitor

Once you've found your best shots, it's time to edit them for printing, right? Well, not quite. If you spend a few moments adjusting your monitor before you fiddle with your pictures, you'll be that much closer to ensuring that what you see on your screen will look like what comes out of the printer.

Calibrating your monitor means that you want it to display colors and tones so that they match a set of standard settings such as gamma and color temperature. By working with standard settings for color, you'll have more confidence that the edits you make to your photos will be reflected accurately when you output them. Keep in mind that an accurate monitor is only part of the equation. Your output device needs to accurately interpret the information you send to it. But good color management begins with a calibrated monitor.

Color management accuracy	Mac OS X	Windows XP, Vista
Fair	Stock monitor profile in Displays Preference pane	Stock monitor profile in Display Properties
Better	Built-in monitor calibrator in Displays Preference pane	Third-party software tool such as Adobe Gamma
Best	Hardware colorimeter	Hardware colorimeter

Monitor calibration options

If you're already using a screen calibration device, such as Pantone's huey ($89; *http://www.pantone.com*) or X-Rite's eye-one Lt ($169; *http://www.xrite.com*), you're in great shape. But if you aren't, don't fret. There are a few workarounds for both Mac and Windows users that can help you calibrate your display. They aren't as accurate, or even as easy as a good colorimeter, but they are free.

Mac OS X includes some handy built-in tools that can get you off to a good start. There are a handful of preset monitor profiles in the Displays Preference pane. Go to your System Preferences, click on Displays, and then click the Color tab. You'll see a list of profiles that you can use for your photography, such as Adobe RGB. You can also create your own profile. While you're still in Displays, click the Calibrate button. Your Mac will walk you through the basic steps of visual color calibration. It's not as accurate as mechanical calibration performed by a colorimeter, but it's a giant step in the right direction.

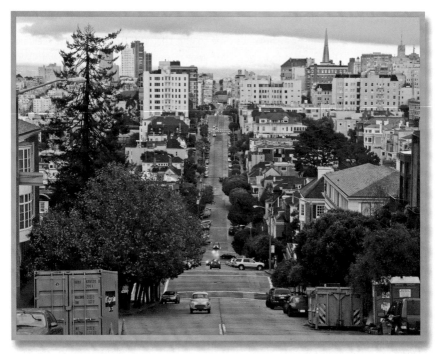

Calibrating your monitor will help to ensure that the colors you see on your screen will render beautifully in your print too.

After you finish the process, you will have created an actual color profile for your monitor that you can choose from the list of other profiles in the Displays Preference pane. You can see the difference between the profile you just created and a stock one included with your Mac (such as Color LCD) by clicking on the two different profiles and noting the differences in how your screen renders colors. It can be quite remarkable.

Windows users also have stock monitor profiles available. If you go to Display Properties→Settings→Advanced and click on Color Management, you'll see the monitor profiles available for your computer.

Even though Windows doesn't have a built-in calibrator, you can use third-party software to help you create a profile. The Adobe Gamma application, for example, that comes with Photoshop is a useful tool for checking the accuracy of your monitor.

XP users can learn more about Adobe Gamma by visiting Adobe Tech Note #321608 (*http://kb.adobe.com*). Vista users can try it too, but with a little more fiddling around. See the weblog post on All Things Adobe (*http://allthingsadobe.libsyn.com/index. php?post_id=230489*) for more information.

But in the end, if you want to get serious about this stage of the color management process, you'll need to invest in a colorimeter. My advice is that you find or create the best profile possible for your computer monitor and follow my other steps for accurate printing. If the results work for you, you're done. If you want to continue to fine-tune the process, investing in a colorimeter is a good first step. I also recommend that you recalibrate about four times per year or before very important printing sessions.

Improving Your Photography through Printing

You've read a lot of information about printing in the past few minutes. You may be thinking, "Why bother?" Well, I feel that printing your work makes you a better photographer.

When you print an image and hang it on the wall, you'll look at it more than if you left it buried deep in your computer. And if you look at your best pictures more, you're going to discover strengths and weaknesses about your craft that you might otherwise miss.

A print is art. Proudly display your skill and vision for others to enjoy.

The combination of ink and paper will reveal details and subtleties that you might otherwise miss. You'll probably have more conversations about your work because it's more accessible to visitors as they drop by. Prints provide us with much-needed "quality time" with our pictures.

So, regardless of whether you're interested in 4×6-inch snapshots to share with family, or 13×19-inch enlargements to set on the coffee table, I hope this chapter has inspired you to revisit printing.

Appendix

Exposure compensation reference guide

Lighting situation	Recommended exposure compensation (via the scale setting)
Subject against a bright-sky background (high clouds on a sunny day)	Overexpose by 2 (+2.0); use fill flash if within 10 feet
Light object (white color), front-lit	Overexpose by 1.5 (+1.5)
Subject against white sand or snow (e.g., person skiing)	Overexpose by 1.5 (+1.5)
Landscape scene dominated by a bright, hazy sky	Overexpose by 1 (+1.0)
Fair-skinned subjects with bright front lighting	Overexpose by .5 (+.5)
Subject against green foliage in open sun (e.g., outdoor portrait with background trees and shrubs)	No compensation
Dark-skinned subjects with bright front lighting	Underexpose by .5 (−.5)
Brightly-lit subject against dark background (e.g., theater lighting)	Underexpose by 1 (−1.0)
Dark object (black color), front-lit	Underexpose by 1.5 (−1.5)

Flash mode settings

Situation	Recommended flash mode*
Outdoor portrait in open shade or sun	Fill flash (flash forced on)
Subject against bright background, such as hazy sky	Fill flash (flash forced on)
Weddings and other special events (both indoor and outdoor shooting)	Fill flash (flash forced on)
Subject in brightly lit evening scene, such as Times Square, New York, or Sunset Strip, Las Vegas	Slow-synchro flash (hold camera steady or use tripod)
Portrait against twilight sky, brightly-lit monument, or building	Slow-synchro flash (hold camera steady or use tripod)
Portrait in brightly-lit room where ambient lighting needs to be preserved	Slow-synchro flash (hold camera steady or use tripod)
Subject who typically blinks as flash fires	Red eye reduction flash (to eliminate recorded blinking)
Mood portrait by window, bright lamp, or other light source	Flash off (steady camera with tripod or other support)
Sporting event or outdoor concert when shooting from the stands	Flash off (steady camera with tripod or other support)

* On some point-and-shoot cameras, these flash settings are accessible only when you enable manual mode. Cameras typically ship in automatic mode, which limits the number of adjustments that the photographer can change. Refer to your owner's manual for more information.

White balance settings

Lighting condition	Recommended white balance setting
Sunny, outdoor conditions	Auto or Daylight
Open shade (e.g., under a tree), indoor portraits by window light, or when flash is on indoors	Cloudy (add fill flash when possible)
Snow setting, bluish winter light, or when overall light balance is too cool	Cloudy
Indoors with flash off, when dominant light source is tungsten light	Tungsten
Outdoors at sunset or sunrise, when light is too warm	Tungsten
Indoors, when dominant light source is fluorescent tubes	Fluorescent

Metering modes with explanations

Metering mode*	Explanation
Evaluative metering	Camera divides viewing area into segments and evaluates each area alone and in combination with others. End result is very accurate overall exposure for most scenes. Good choice for general photography.
Spot metering	Camera reads only center portion of viewing area, usually within the center brackets or crosshairs. Good choice for situations that require precise exposure control on a particular element in the scene. Most popular use is to correctly meter a person's face in difficult lighting situations.
Center-weighted metering	Camera reads entire viewfinder area, but with more emphasis placed on central portion of scene. Typically used for landscape and general photography. Evaluative metering is usually preferred over center-weighted metering.

* Many point-and-shoot cameras offer only one metering mode—usually center-weighted or evaluative. Intermediate and advanced models usually include spot metering too.

Camera modes with explanations

Camera mode*	Explanation
Programmed autoexposure (P)	Camera sets both aperture and shutter speed. Good for general photography.
Shutter priority/ timed value (S or Tv)	Photographer sets shutter speed and camera sets corresponding aperture. Best for action, sports, or running water photography.
Aperture priority/ aperture value (Av)	Photographer sets aperture and camera sets corresponding shutter speed. Best for landscape photography or any situation that requires depth-of-field control.
Manual (M)	Photographer sets both aperture and shutter speed. Advanced mode for those with an understanding of photography.
Movie	Camera records video segments and saves them as QuickTime, AVI, or MPEG files. Some models also record sound to accompany the video.
Panorama	Camera designates a sequence of shots to be stitched together later to create one image with a wide perspective. Some cameras give you onscreen assistance to line up the sequence.
Nighttime	Allows for longer shutter speeds (even when the flash is turned on) to enable photography in low ambient light, such as at sunset or for brightly-lit interiors. A tripod should be used to help steady the camera when using this mode.

* Your camera may have all, some, or only a couple of these modes available. Typically, aperture priority, shutter priority, and manual modes are available only on advanced models.

*Exposure starting points for sunset and astrophotography**

Subject	ISO speed	Aperture (f-stop)	Shutter speed
Sunset (point at sky without sun shining in viewfinder)	100	Programmed autoexposure	Programmed autoexposure
Full moon	100	f/8	1/250–1/500 of a second
Quarter moon	100	f/5.6	1/125–1/250 of a second
Total lunar eclipse	200	f/2.8	2 seconds (use tripod)
Half lunar eclipse	200	f/4	1 second (use tripod)
Aurora borealis	200	f/2.8	2–30 seconds, depending on intensity (use tripod)
Star trails	100	f/4	10 minutes or longer (use tripod)
Meteors	100	f/5.6	30 minutes or longer (use tripod)

* The settings in this table should serve only as starting points for astrophotography. Allow ample time for testing with your equipment and conditions for optimal results.

Megapixels-to-print-size reference

Camera type	2 MP	3 MP	4 MP	6.3 MP	8 MP
Photo-quality	5x7 inches	8x10 inches	10x12 inches	11x14 inches	14x16 inches
Acceptable	8x10 inches	10x12 inches	11x14 inches	14x16 inches	16x20 inches

Scene modes are a collection of settings that help you get the best shot in a variety of conditions. You can also use them as shortcuts in any situation that suits you. This table will help you understand the basic settings in common scene modes.

Scene mode information

Scene mode	ISO	Flash	Drive	White balance
Portrait	Low	Auto	Single	Auto
Landscape	Low	Off	Single	Auto
Night Scene	Low	Auto (metered for person)	Single	Auto
Sports	Very high	Off	Continuous	Auto
Kids and pets	High	Auto	Single	Auto
Indoor (party)	High	Auto	Single	Auto, but aware of tungsten and fluorescent
Snow	Low	Auto	Single	Warm
Beach	Low	Auto	Single	Auto
Fireworks	Low	Off	Single	Auto
Aquarium	Very high	Off	Single	Auto, but aware of artificial lighting

Shutter speed	Depth of field	Comments
Average	Shallow	Best for solo portraits
Average	Deep	For any situation requiring deep depth of field
Slow	Average	Flash portraits with low light backgrounds
Fast	Shallow	Action shots without flash
Average	Average	Action shots with flash
Average	Average	Indoor scenes that retain some background
Average	Average	Bright conditions that require warmer white balance
Average	Average	Bright conditions that do not require warm white balance
Very slow	Average	Requires tripod
Fast	Average	Place front of lens against aquarium glass to minimize reflections

Color temperature chart in Kelvin

Degrees Kelvin	Type of light source
1700–1800K	Match flame
1800–2200K	Dawn, dusk, candle flame
2400–2600K	40W incandescent bulb
2800–3000K	100W incandescent bulb
3200–3400K	500W photoflood bulb, quartz bulb
4200K	Sun at 20 degrees altitude, cool white fluorescent bulb
5400K	Sun at noon
5500K	Photographic daylight
5500–6000K	Hazy sun, photo electronic flash, HMI lamp, neon bulb
6500–7000K	Bright sun, daylight fluorescent bulb
8000–9000K	Open shade outdoors, overcast sky
9000–10000K	North light, skylight window

*Number of pictures to capacity of memory card reference**

Camera resolution	1600x 1200 (2 MP) How many pictures	2048x 1536 (3.3 MP) How many pictures	2272x 1704 (4 MP) How many pictures	2560x 1920 (5 MP) How many pictures	3072x 2048 (6.3 MP) How many pictures	3456x 2305 (8 MP) How many pictures
Card capacity						
32 MB	20	17	15	13	11	8
64 MB	40	35	30	26	23	17
128 MB	82	71	61	54	48	36
256 MB	180	143	123	110	101	72
512 MB	370	287	247	221	203	145
1 GB	727	575	494	443	409	293
2 GB	1456	1150	989	887	820	588
4 GB	2910	2302	1980	1776	1642	1178

* The number of pictures listed for each memory card size in this table is for images saved at the highest-quality setting in the JPEG format. You can squeeze more pictures onto a card by lowering the quality setting, but this is not recommended. Different camera brands may produce results slightly different from those shown here.

Available Metadata for the Photographs in this Book

Image	Camera Model	Focal Length	ISO/Aperture/ Shutter Speed	Photographer/ Location
	Canon EOS 5D	300mm	ISO400 f/9.5 1/750	Derrick Story Northern California
	Canon EOS 5D	265mm	ISO100 f/8 1/90	Derrick Story Iceland
	Canon PowerShot G1	221mm	f/4 1/400	Derrick Story San Francisco, California
	Canon EOS 5D	60mm	ISO100 f/9.5 1/250	Derrick Story Iceland
	Panasonic DMC-TZ5	528mm	ISO100 f/3.3 1/250	Derrick Story Hoover Dam, Nevada
	Canon PowerShot SD700 IS	14mm	ISO80 f/4 1/60	Derrick Story Guatemala

Available Metadata for the Photographs in this Book (continued)

Image	Camera Model	Focal Length	ISO/Aperture/ Shutter Speed	Photographer/ Location
	Canon PowerShot G9	7mm	ISO100 f/4 8.0s	Derrick Story Tampa, Florida
	Canon EOS 5D	200mm	ISO200 f/6.7 1/500	Derrick Story San Francisco, California
	Hasselblad CF528-39 - Rollei Lens Control S		ISO50 f/22 1/60	Magnus Palmér
	Canon PowerShot G9	22mm	ISO100 f/4 1/320	Derrick Story Santa Rosa, California
	Canon EOS DIGITAL REBEL XTi	163mm	ISO400 f/5.6 1/350	Derrick Story Seattle, Washington
	Canon EOS 5D	200mm	ISO250 f/6.7 1/500	Derrick Story Sebastopol, California
	Canon DIGITAL IXUS 800 IS	6mm	f/5.6 1/320	Ruth Cooper

Available Metadata for the Photographs in this Book (continued)

Image	Camera Model	Focal Length	ISO/Aperture/ Shutter Speed	Photographer/ Location
	Canon EOS 5D	105mm	ISO200 f/9.5 1/500	Derrick Story, Reyholt, Iceland
	Canon PowerShot S400	7mm	f/2.8 1/160	Derrick StoryBoston, Massachusetts
	Canon PowerShot SD700 IS	9mm	f/6.3 1/400	Derrick Story De Palm Island
	Canon PowerShot G9	17mm	ISO100 f/5.6 1/125	Derrick Story Santa Rosa, California
	Canon EOS 5D	105mm	ISO320 f/6.7 1/200	Derrick Story Mill Valley, California
	Panasonic DMC-FZ8	400mm	ISO400 f/3.3 1/30	Derrick Story Santa Rosa, California
	Canon PowerShot G9	7mm	ISO80 f/4 1/250	Derrick Story Off the coast of Aruba

Available Metadata for the Photographs in this Book (continued)

Image	Camera Model	Focal Length	ISO/Aperture/ Shutter Speed	Photographer/ Location
	Canon EOS DIGITAL REBEL XTi	17mm	ISO100 f/8 1/125	Derrick Story San Francisco, California
	Canon EOS DIGITAL REBEL XTi	35mm	ISO400 f/4 1/15	Derrick Story Las Vegas, Nevada
	Canon EOS 10D	22mm	ISO100 f/4 4.0sec	Derrick Story, Burney Falls, California
	Canon Rebel XTi	42mm	ISO100 f/8 1/180	Derrick Story Seattle, Washington
	Canon EOS 5D	16mm	ISO100 f/16 1/60	Derrick Story San Francisco, California
	Canon EOS 5D	85mm	ISO800 f/9.5 1/200	Derrick Story, Newport Beach, California
	Canon EOS DIGITAL REBEL XT	85mm	ISO100 f/5.6 1/60	Derrick Story Santa Rosa, California

Available Metadata for the Photographs in this Book (continued)

Image	Camera Model	Focal Length	ISO/Aperture/ Shutter Speed	Photographer/ Location
	Canon EOS 5D	188mm	ISO250 f/4.5 1/250	Derrick Story Santa Rosa, California
	Canon EOS 5D	80mm	ISO400 f/5.6 1/250	Derrick Story Bodega Bay, California
	Canon EOS 5D	17mm	ISO100 f/8 1/125	Derrick Story Santa Rosa, California
	Canon EOS 20D	68mm	ISO800 f/4 1/200	Paige Green Santa Rosa, California
	Canon EOS 5D	17mm	ISO400 f/8 1/250	Derrick Story Sebastopol, California
	Canon EOS DIGITAL REBEL XT	22mm	ISO200 f/9.5 1/180	Derrick Story Sebastopol, California

Available Metadata for the Photographs in this Book (continued)

Image	Camera Model	Focal Length	ISO/Aperture/ Shutter Speed	Photographer/ Location
	Canon PowerShot G2	21mm	ISO50 f/6.3 1/100	Derrick Story Sebastopol, California
	Olympus C3030Z	19mm	ISO100 f/3.6 1/250	Derrick Story Santa Fe, New Mexico
	Canon EOS 10D	70mm	ISO400	Paige Green Santa Rosa, California
	Canon EOS DIGITAL REBEL XTi	24mm	ISO200 f/9.5 1/250	Derrick Story Hollywood, California
	Canon PowerShot G9	7mm	ISO400 f/2.8 1/6	Derrick Story Tampa, Florida
	Canon EOS DIGITAL REBEL XT	18mm	ISO100 f/4.5 1/60	Derrick Story San Francisco
	Canon EOS 5D	85mm	ISO400 f/1.8 1/60	Derrick Story Sebastopol, California

Available Metadata for the Photographs in this Book (continued)

Image	Camera Model	Focal Length	ISO/Aperture/ Shutter Speed	Photographer/ Location
	Canon EOS DIGITAL REBEL XT	300mm	ISO1600 f/5.6 1/180	Derrick Story Oakland, California
	Canon PowerShot G9	7mm	ISO200 f/5.6 1/50	Derrick Story Sebastopol, California
	Canon PowerShot G9	17mm	ISO200 f/4 1/25	Derrick Story Sebastopol, California
	Canon PowerShot G1	7mm	f/2 1/8	Derrick Story Lake County, California
	Canon EOS DIGITAL REBEL XT	18mm	ISO100 f/8 3.2s	Brian C Davenport Detroit, Michigan
	Canon EOS DIGITAL REBEL XTi	56mm	ISO400 f/4.5 1/90	Derrick Story Santa Rosa, California
	Canon EOS 5D	50mm	ISO250 f/4 1/250	Derrick Story Santa Rosa, California

Available Metadata for the Photographs in this Book (continued)

Image	Camera Model	Focal Length	ISO/Aperture/ Shutter Speed	Photographer/ Location
	Canon PowerShot SD700 IS (with Canon Underwater Housing)	6mm	f/2.8 1/400	Derrick Story Santa Rosa, California
	Canon EOS 5D	200mm	ISO250 f/5.6 1/350	Derrick Story Sebastopol, California
	Sony Ericsson W810i		ISO8D f/2.8 1/5000	Derrick Story San Francisco, California
	Canon PowerShot G9	29mm	ISO80 f/4 0.5s	Derrick Story New York, New York
	Canon EOS DIGITAL REBEL XTi	200mm	ISO400 f/4 1/90	Derrick Story Seattle, Washington
	Canon EOS DIGITAL REBEL XTi	24mm	ISO400 f/5.6 1/90	Derrick Story Huntington Beach, California

Image	Camera Model	Focal Length	ISO/Aperture/ Shutter Speed	Photographer/ Location
	Canon PowerShot SD700 IS	6mm	f/2.8 1/15	Derrick Story Seattle, Washington
	Canon PowerShot G9	19mm	ISO200 f/3.5 1/100	Derrick Story San Francisco, California
	Canon EOS DIGITAL REBEL XT	105mm	ISO400 f/4 1/125	Derrick Story Mexico
	Canon EOS 5D	24mm	ISO100 f/8 1/125	Derrick Story, Mexico
	Canon EOS 10D	135mm	ISO100 f/8, 1/30	Derrick Story, Sonoma County, California
	Casio EX-P505	6.3mm	ISO200 f/3.7 1/320	Derrick Story San Jose, California

Index

AMERICA AT HOME

Created by Rick Smolan and Jennifer Erwitt

HUNDREDS OF THOUSANDS OF SIMULTANEOUS SNAPSHOTS SHOW WHAT "HOME" MEANS TO AMERICANS

For one week, 100 professional photographers and tens of thousands of amateurs from across the country were encouraged to capture photos of what home means to them. The result is a compelling photo book that captures the extraordinary diversity of American home life— the emotions, rituals and events that make a house a home.

Make **AMERICA AT HOME** your own by uploading your photo of your home or family to create a custom book jacket for your own copy of the book. To learn more, or to simply see what your photo would look like on the cover (it costs nothing until you actually place an order) go to **www.MyAmericaAtHome.com**

1 Take a digital photo of your kids, pets, parents, or scan your favorite photo or an old black and white photo of the house where you grew up.

2 Visit our website at www.MyAmericaAtHome.com and see how easy it is to upload, crop, and caption your image. Transform your photo into a personalized cover.

3 You'll get a glossy book jacket that looks exactly like the original AMERICA AT HOME cover, featuring your photo on the cover and your caption on the inside flap.